APERTURE

Between Past and Future: New German Photography

Now that the giddy celebrations that marked reunification have ended, Germany finds itself still confronted by unresolved questions of its past and its hopeful but uncertain future. "Between Past and Future: New German Photography" examines the state of Germany today, as well as the tremendously varied photography being produced there. From Bernhard Prinz's stylized portraits to the performance-based work of Dieter Appelt, from Johannes Brus's combinations of photography and painting to Thomas Florschuetz's close-ups of facial details, German photography today is a vital expression of a society flush with a new sense of possibility.

Over the past two decades Germany has witnessed the rise of an extraordinarily vital cultural scene, as a new generation of painters, photographers, filmmakers, and others have combined an awareness of the traditions of German art with concern over contemporary German society. As Klaus Honnef points out, the dynamic photography scene in Germany today has developed out of the rich heritage of German photography in this century. Enno Kaufhold and Wilfried Wiegand discuss two primary strains of German photography today, the Apollonian and the Dionysian, each reflecting a central aspect of the German character.

Other writers here reflect on Germany's history, and on its dramatically changed situation. Novelist Martin Walser tells of a young man whose entire past, embodied in family photographs, is destroyed in the firebombing of Dresden during World War II. Ulf Erdmann Ziegler addresses the dark legacy of urban terrorism that struck Germany in the 1970s, while Christoph Tannert looks back on the forty-year history of the German Democratic Republic, a.k.a. East Germany, and what the Communist regime meant to photographers. Reunification brings with it a revival of national pride—but also fearful memories of the consequences of extreme nationalism. The photographers and writers in this issue present a new Germany, aware of its past but looking to a bright future.

In assembling the pictures and articles for this issue, a distinguished group of advisors in Germany have provided invaluable help and advice. We wish to express our deep appreciation for their assistance: Ulrich Domröse, historian and collector, East Berlin; Ute Eskildsen, Folkwang Museum, Essen; Janos Frecot, Berlinische Galerie, Berlin; F.C. Gundlach, PPS. Galerie, Hamburg; Manfred Heiting, Fotografie Forum Frankfurt; Klaus Honnef, Rheinisches Landesmuseum, Bonn; and Peter Weiermair, Frankfurter Kunstverein.

This issue is made possible with the generous financial support of the National Endowment for the Arts and of Agfa Corporation, whose vision in helping to underwrite significant projects in photography reflects their continuing commitment to the finest expressions of the medium.

The trustees and staff of Aperture wish to express their gratitude to Eelco Wolf, Vice President Corporate Communications of Agfa. His guidance and deep understanding of photography at its highest aspirations continues as a sustaining force.

THE EDITORS

Reclaiming a Legacy:
Photography in Germany and German History

By Klaus Honnef

From the glories of Berlin's Golden Twenties, to the nadir of the Nazi Era, to the renewal of art and society after World War II—the path of German photography in this century has paralleled the history of the country itself.

Photography in Germany can look back on a grand tradition. In the twentieth century, German photographers have made essential contributions to the history of the medium. The years after World War I produced an extraordinarily rich cultural climate, fueled by the efforts of artists and intellectuals to distance themselves from the prewar hierarchical society of Prussian militarism. A willingness to run aesthetic risks and a technological innovativeness led to a tremendous flowering of the medium. With the slogan of "New Vision," German photographers and artists, together with their Russian colleagues, renewed the visual language of photography. In Berlin, Cologne, and Munich, photojournalism developed on a large scale; in Weimar and Dessau, the Bauhaus taught experimental photography; on the Rhine and the Ruhr, photographers like August Sander, Albert Renger-Patzsch, and Werner Mantz created a sober, objectively tinged visual idiom, laying the foundations for an encyclopedically oriented conception of the image—an approach that is still evolving in the photographic oeuvre of Hilla and Bernd Becher as well as countless American photographers. The history of photography during those years reflected a profound change in the human image: whether in Hugo Erfurth's portraits, made within the realm of artistic photography, or August Sander's incisive type-portraits, which carried out an analysis along the lines of the *Neue Sachlichkeit* (Neo-Realism). This change paralleled similar shifts in attitude toward empirical reality occurring throughout visual art.

In close contact with painter friends, Sander, whose earlier work was dictated by the premises of art photography, developed his ambitious project: a topological pictorial atlas of the society of the Weimar Republic. Meanwhile, Renger-Patzsch, emphasizing the technological structure of the medium, formulated his photographic notions in resolute contrast to the then-

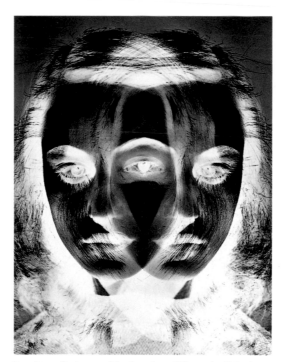

Dr. Otto Steinert, *Maske einer Tänzerin* (Mask of a dancer), 1952

dominant ideology of art photography. According to his aesthetic credo, photography would simply "recognize, record. If it tries to interpret, it is already overstepping its boundaries. It should leave interpretation to art."[1]

Volume 8 of the renowned Bauhaus Books was Laszlo Moholy-Nagy's theoretical manifesto *Painting Photography Film*. Here, with the help of words and images, Moholy-Nagy (who, despite claims to the contrary, did not teach the Bauhaus photography class) explored the creative potential of photography, which, he felt, had been barely reconnoitered. His foreword proclaimed: "The camera has provided us with surprising possibilities, which we are only just beginning to exploit. In expanding the visual picture, even the present-day lens is no longer bound to the limits of our eyes; no manual device for shaping (pencil, brush, etc.) can capture similarly seen slices of the world."[2] The new explorations of the medium were thus accompanied by equally far-reaching critical and theoretical investigations of all sorts.

A contest involving some thousand works by more than two hundred photographers, the legendary exhibition *Film and Photo* was mounted by the German Labor Alliance in 1929. The show, presented in Stuttgart, documented the high aesthetic standard that had been achieved by postwar German photography and cinema in virtually all areas of application. (Photojournalism, which was only just emerging in Berlin, Munich, Leipzig, and Cologne, did not come to its full fruition until the early 1930s.)

The events taking place in a faraway Germany did not elude attentive observers in the United States. Two years after the Stuttgart show, Walker Evans, under the title "The Reappearance of Photography," reviewed six photo books in the magazine *Hound and Horn*. Three of these books were German: Renger-Patzsch's *Die Welt ist schön* (The world is beauti-

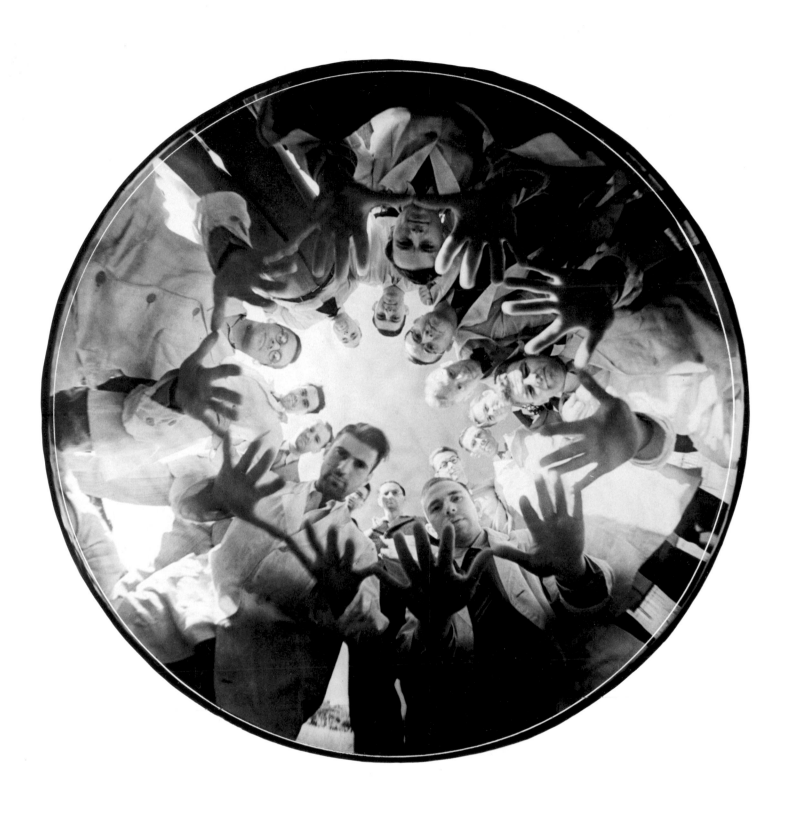

UMBO, *Die Himmelskamera* (Sky camera), 1937

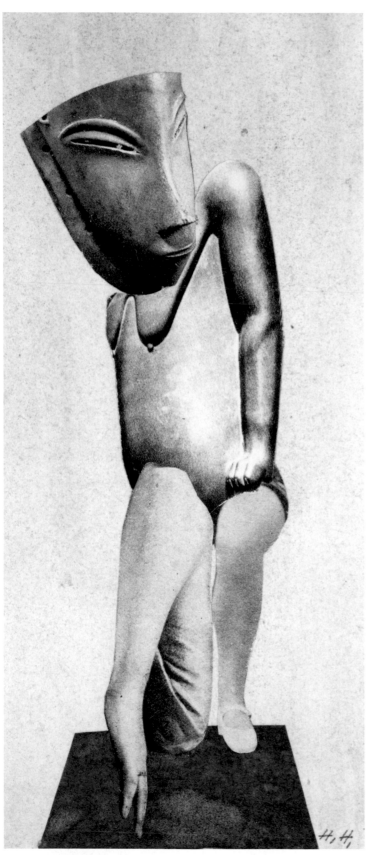

Hannah Höch, *Denkmal I, Aus einem ethnografischen Museum VIII* (Monument I, from an ethnographic museum VIII), 1924

ful); Franz Roh and Jan Tschichold's *foto-auge* (photo-eye); and August Sander's *Antlitz der Zeit; Sechzig Aufnahmen deutscher Menschen des 20. Jahrhunderts* (Face of the times; sixty photos of German people of the twentieth century). Before zeroing in on the individual books, Evans bluntly declared:

> Without money, postwar Germany experimented with photography heavily and thoroughly. There was an efficient destruction of romantic art-photography in a flood of new things which has since lost its force. But the medium was extended and insisted upon, even though no German master appeared. The German photo renascence is a publishing venture with political undertones.[3]

Even though Evans was unable to perceive any "master" in German photography, he admitted that Sander's book was more than just a volume of type-studies:

> Finally the photo-document is directed into a volume, again in Germany. *Antlitz der Zeit* is more than a book of "type studies"; a case of the camera looking in the right direction among people. This is one of the futures of photography foretold by Atget. It is a photographic editing of society, a clinical process; enough of a cultural necessity to make one wonder why other so-called advanced countries of the world have not also been examined and recorded.[4]

In Berlin in these years, creative minds from all over Europe were colliding with one another, creating an electrifying atmosphere. This climate was documented on the pages of the illustrated magazines, whose circulation skyrocketed. Photojournalism was not born in Germany, but it was here that it attained its first El Dorado. Well-known figures such as Erich Salomon, Felix H. Man, Martin Munkacsi, Alfred Eisenstaedt, Wolfgang Weber, Harald Lerchenperg, the Gidal brothers, and the Capa brothers (Robert and Cornell) are representative of others, like Sasha Stone, who are now largely forgotten. From eastern and southeastern Europe, young artists and intellectuals poured into Berlin, functioning somewhat as a yeast in the fermenting cultural dough of the city. Art and literature, theater and music, photography and cinema forged the legend of Berlin's Golden '20s. Dada, the anti-artistic movement that radically declared war on the bourgeois concept of art, had a far more political coloring in the German capital than in Zürich or Paris. In structural terms, George Grosz's drawings with their acid social critique, Hannah Höch's razor-sharp collages, and John Heartfield's aggressive political montages rejected the illusionist outlook of traditional art. The new mode of representation appropriately reflected the social conflicts of the day as well as the new complex scientific and technological view of the world.

In cinema and photography, a specific "Berlin style" crystallized, a pictorial language of which only vestiges remain. The

Heinz Hajek-Halke, *Fashion Photograph*, c. 1930

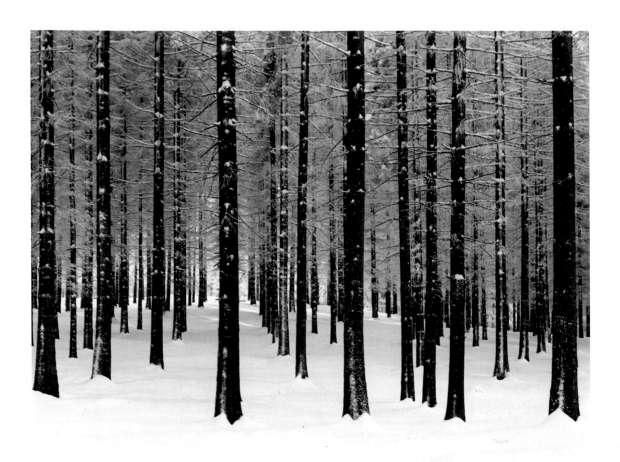

Albert Renger-Patzsch, *Tannenwald im Winter* (Fir wood in winter), 1956

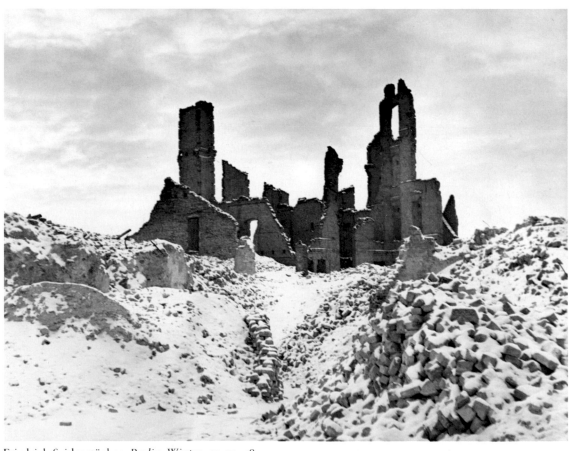

Friedrich Seidenstücker, *Berlin, Winter*, 1947–48

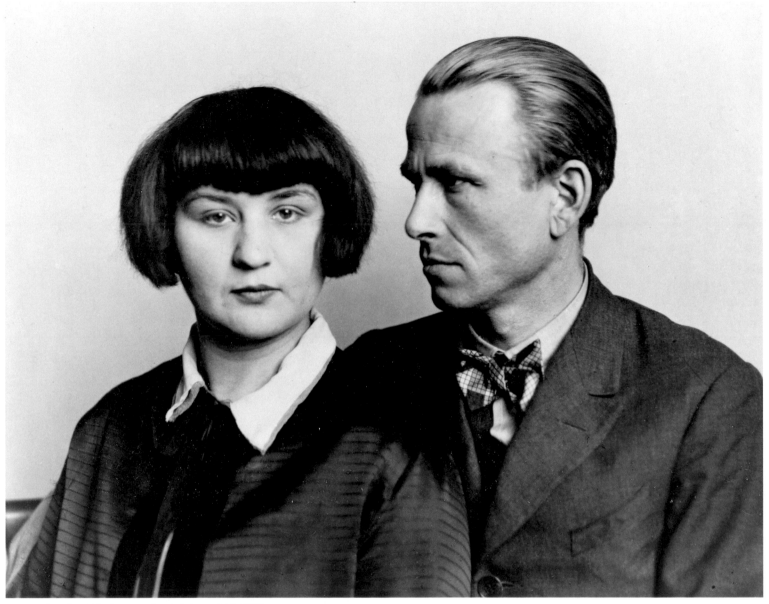

August Sander, *The Painter Otto Dix and his Wife*, 1928

Nothing is more hateful to me than photography sugar-coated with gimmicks, poses, and false effects. Therefore let me speak the truth in all honesty about our age and the people of our age. . . .

<div align="right">AUGUST SANDER, 1927</div>

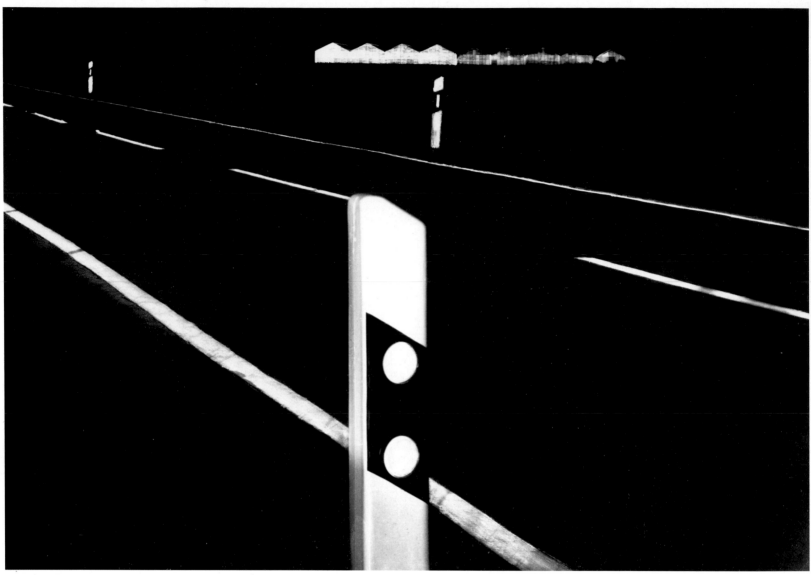

Robert Häusser, *Relative Orientierung* (Relative orientation), 1972

*The camera sees only what I see. But what the camera sees has to be identical to
the observer's image of reality. There is no such thing as objective photography.*

ROBERT HÄUSSER

American film noir of the 1940s and '50s, whose directors and cameramen were mostly German immigrants, and the photographic oeuvre of Helmut Newton, a native Berliner, preserved this characteristic diction with its deep shadows and violent contrasts of black and white. Far from expressing uncritical enthusiasm about the machine world of the industrial era (of the sort that marked Italian Futurism), the works of the photographic vanguard in Germany evinced a deep understanding of the technological limits and possibilities of the medium and the modern age. A direct photographic approach to reality was accompanied by an unvarnished conception of material objects. "Things" was the original title of Renger-Patzsch's book, which finally bore the questionable name of *The World Is Beautiful*. The spectrum of photographic activity ranged from the reportages of magazine photographers and the *Neue Sachlichkeit* photos taken by the critical analysts to the lovingly shaped photographic impressions of Friedrich Seidenstücker, whose extremely erotic nudes have still not been adequately appreciated; the experimental pictures of Heinz Hajek-Halke, who actually ventured into the scientific terrain

of biology; and the seductive fashion tableaux made in Yva's studio, where Helmut Newton learned his craft.

When the National Socialists used an appeal to law and order to abolish artistic freedom, vast numbers of photographers and filmmakers left Germany; others, refusing to believe the ominous announcements, paid for their trust with their lives. Still others, like Renger-Patzsch, Weber, Lerchenperg, and even Sander, retreated into a sort of "inner emigration" or else went on extended trips throughout the world. The night of terror and war descended upon Germany, and German photography was forever branded: aside from a few shots by amateurs and by the perpetrators themselves, almost nothing of the horrifying events of the Nazi period was captured in photos. For twelve years, German photography capitulated to the visible historical reality.

In a divided postwar Germany, photography recovered only very slowly from the blood-letting—the expulsion and annihilation of the most innovative minds in art, literature, photography, and cinema. While the advanced photographers in the free portion of Germany were able to draw on the experimental approaches of Bauhaus photography, and photojournalists like Wolfgang Weber and portraitists like Liselotte Strelow generally remained apolitical, photography east of the Elbe River was co-opted by Communist propaganda. The buzzword "Subjective Photography," adapted by a group of photographers in the 1950s and '60s who emphasized the expressive aspects of photography over the documentary, points out the direction taken by many in the Western occupation zones and the later Federal Republic of West Germany. Otto Steinert, the outstanding representative of the subjectivistic stance and also its eloquent champion, rallied a group of young German photographers around himself, showing them in a few successful exhibitions and paving the way for contacts with like-minded photographers in other Western countries. For many of these photographers, in Germany and elsewhere, empirical reality—the realization of the historical process—was merely a foil for technically brilliant formal exercises. Compared with the New Vision of the 1920s, "subjective photography" did not produce any fundamental expansion of photographic language. At the same time Robert Häusser, an outsider just as Seidenstücker had been, cultivated a surreal, traumatic view; his impressive pictures, inspired partly by his intense friendships with the German painters of the Informel group, offered variations on the categorical premises of "subjective photography." On the other hand, Strelow's incisive, psychologizing portraits managed to salvage at least a hint of the "Berlin style" of German photography for the postwar era.

The cultural weight of a no-longer-divided Germany has gradually shifted westward, to the Rhine. Meanwhile Berlin, which may once more be facing a great future, has sunk down into a cultural province—at best a paradise for social desperadoes and nostalgia buffs. For the time being, the question of

how great a cultural clout East Germany can have must remain open. The lack of a true center has had an extraordinarily positive effect on postwar German history. Jürgen Habermas's notion of the "new non-lucidity" may also be applied to the field of photography, but recently, several powerful trends have developed, testifying to the vitality of the German photography scene. In Düsseldorf, Bernd and Hilla Becher, initially applauded only by the art world, have established a new school of photography with their sequences of pictures showing buildings characteristic of industrial architecture. Names like Thomas Ruff, Thomas Struth, Axel Hütte, and Candida Höfer can boast of growing reputations among the photographic public. In Kassel and Bielefeld, Floris M. Neusüss and Gottfried Jäger have joined the tradition of German experimental photography. Neusüss has continued the technical development of the photogram, while Jäger has created "generative photography." Angela Neuke in Essen has opened new perspectives for photojournalism; like many of her earlier fellow students, this disciple of Otto Steinert has marked the physiognomy of contemporary photojournalism in Germany for years to come. Thomas Höpker, Robert Lebeck, and Ulrich Mack have also provided critical accents for German photojournalism. The line of art photography has been extended by Arno Jansen's morbid still lifes and ingenious female portraits.

German photography has received extremely fruitful impulses from vanguard art. An influential figure in this context is Sigmar Polke. His innovative treatment of photography as a medium has had both a crystallizing and a liberating impact. Other artists such as Jürgen Klauke and Bernhard Johannes Blume have come to photography through such areas as performance art and Conceptualism. They all share an attitude of critical distanciation toward the medium and its mass distribution. At the same time they have extended the boundaries of photography, releasing it from the constraint of a philistine technique of reproduction. That their seeds have fallen upon fertile soil is suggested by, say, the crumbling of ossified structures in the photography of the former GDR. To this extent, Thomas Florschuetz's oeuvre is only the tip of an iceberg whose expanse we are as yet unable to survey.

Photography in Germany or German photography? The question awaits clarification. There are many signs that photography as a medium has evolved a specific German accent. The latter may not be as self-sufficient as the spoken and the written language; but it is nevertheless unmistakable. □

1. Quoted in Fritz Kempe, Catalogue for Albert Renger-Patzsch (Essen, 1966).
2. Laszlo Moholy-Nagy, *Malerei Fotografie Film* (Painting photography film), new edition (Mainz and Berlin, 1967), p. 5.
3. Walker Evans, "The Reappearance of Photography," in *Hound and Horn*, Oct.-Dec. 1931, vol. V, no. 1, pp. 125–128.
4. Op. cit.

Translated from German by Joachim Neugroschel.

Another German Autumn

By Ulf Erdmann Ziegler

Amidst the euphoria of reunification, Ulf Erdmann Ziegler reflects on the 1970s, when discontent with West German consumer society sparked a campaign of urban terrorism—revealing contradictory attitudes toward the question of Germany's moral responsibilities.

Whenever a German runs into another German, be it on the Spanish Mediterranean coast or in downtown Manhattan, he turns away and stops talking. Being German is already an embarrassment, but it is the presence of the other German that makes being German unbearable. The hatred felt toward American tourists in Heidelberg or Munich is larded with envy: for they, the Americans, are not ashamed of their language.

When the Federal Republic of Germany was thirty-something and I was twenty-something, France and Sweden were all the rage. France because of its way of life, which had survived as a "style" into the television age; and Sweden because of its social homogeneity. Needless to say, these fads were partly projections. For that very reason, they vividly illustrate what the West Germans wanted to be: nonchalant, traditional, elegant (like the French), caring, trusting, vigorous (like the Swedes). Not that the Germans avoided traveling to other neighboring countries: Holland, Switzerland, Austria, Denmark. But these countries played no decisive role in the West German imagination. Czechoslovakia, Bavaria's southeastern neighbor, was largely ignored—unlike East Germany, which was apostrophized as "the other part of Germany" in the grandiloquent jargon of the unification politicos, but which preferred the abbreviation "GDR."

East Germany's role in the West German mind went through a fundamental shift between the founding of the two states (1949) and the collapse of the East German regime (1989). This shift occurred after 1969, when social democrats and liberals replaced conservatives in the government. The image of a gray GDR, a backward Big Brother state, was modified. After being limned as a monster to West Germans, the GDR was now depicted as a cripple, whom it wouldn't hurt to shake hands with—a cripple whose condition might improve. Although this was quite unlikely, hope was the order of the day. The East German citizens were regarded almost as laboratory animals by numerous members of an enlightened West German society: despite years of intimidation by "their" socialist state, these guinea pigs had supposedly agreed to participate in the experiment of a truly *different* Germany. On the other hand, the nationalistic, conservative newspapers of media tycoon Axel

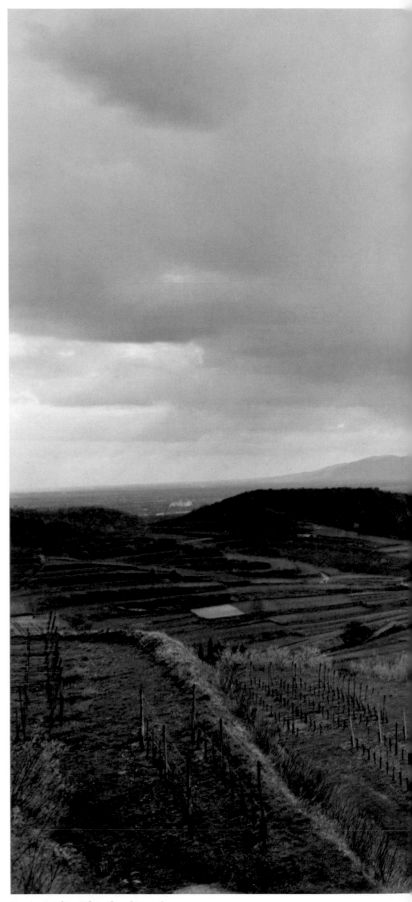

Roger Melis, *Rhineland Landscape*, 1990

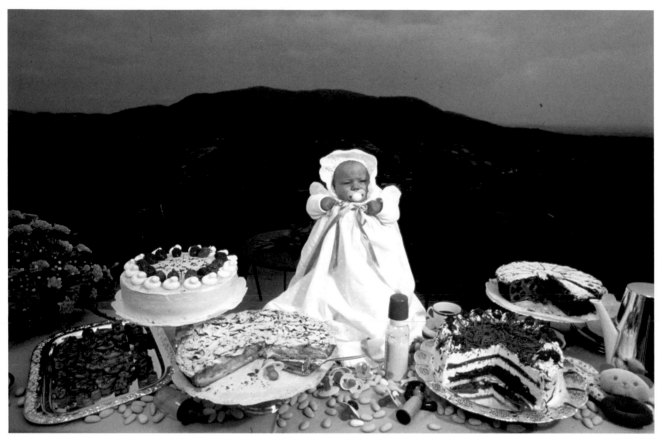

Ellerbrock & Schafft, *Food and Drink in Germany: Christening on the "Stauffenburg"*, 1989

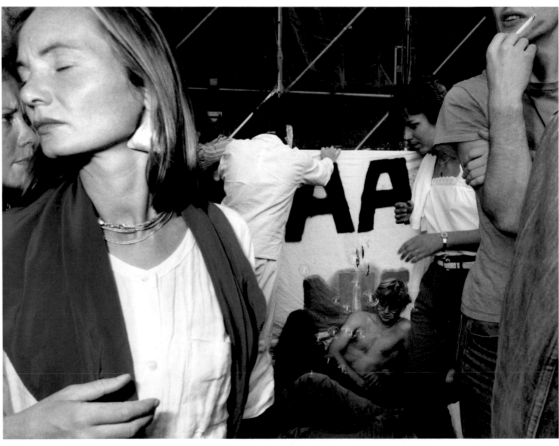

Wolfgang Zurborn, *Untitled*, 1986

Angela Neuke, *Bonn*, 1989

Siegfried Himmer, *Dresden*, 1990

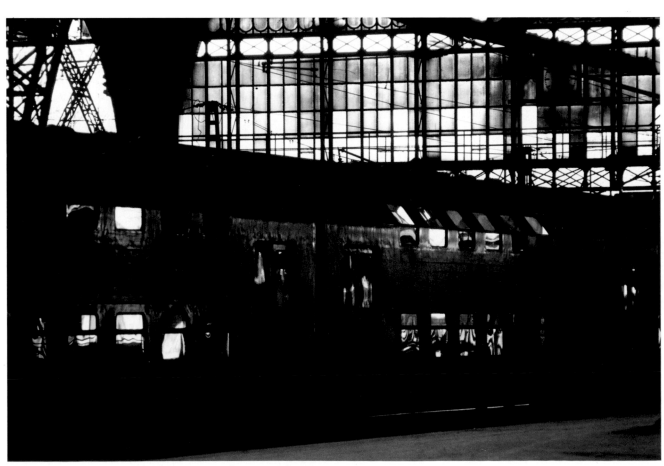

Siegfried Himmer, *Dresden*, 1990

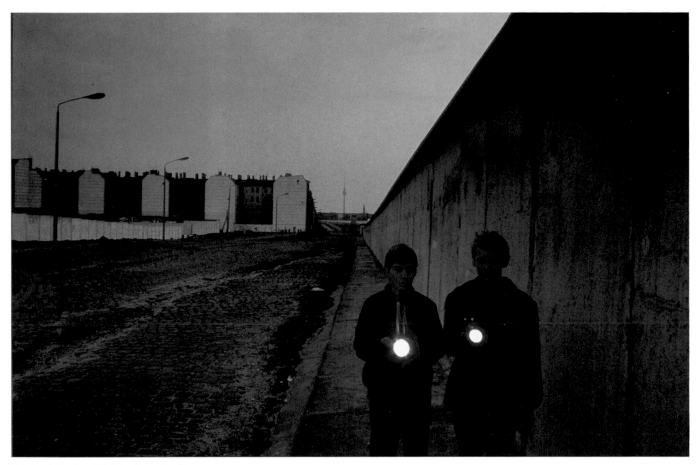

Michael Engler, *Wall in East Berlin*, 1990

Springer continued to print GDR in quotation marks until three years ago—as if this country did not really exist.

While the West Germans took the international route of conformity, the GDR cultivated the heritage of a militaristic Prussia. Since the East Germans, aside from retirees and a few elites, were not allowed to travel outside Warsaw Pact countries, they were never found in New York or on the beaches of Mallorca. They were forced to stay home and drudge. An unmistakable sign of their political and ideological incest was the stench they lived in: that diffuse odor emanating from poor material and cheap household cleansers, which the Eastern nations have preserved until this very day.

In the 1970s, the generation of 1968, whose street actions and demonstrations had frightened West German citizens, began the "march through the institutions." The Nazi past, which had been taboo during the 1950s and '60s, was now revealed: the Holocaust entered school curricula. It was not guilt that was overcome, but much of the repression of the past on which the Konrad Adenauer republic had been built.

It was, I believe, the photographer Alfred Eisenstaedt who observed in the 1970s that West German school children looked like American school children. The dreadful gray of anxiety, which had constituted the power of René Burri's pictures of Germany, was traded in for the colors of an industrial promise of happiness. The West Germans had become what they had wanted to be: like everyone else.

Many West Germans born after the Second World War do not care about East Germany one way or another. Even West Berliners, who had to pass through East Germany in order to reach West Germany, spoke of "the German border"—that was the normal term—whenever they sighted the monstrous border facilities. For many, West Germany had become synonymous with "Germany" per se. Germans were not seeking a political fusion with the German-speaking portion of Switzerland—so why strive toward a union with the backward country in the East, the German Democratic Republic?

However, the estrangement was not just an alienation between systems. The element that might have tied the Germans to one another conceptually and emotionally (before the political shift forced this unification to materialize) was the fact of being "German." Unfortunately, at least until the unification, being German was always associated with the Third Reich. That was one reason why being "German" was not a particularly strong link between the two halves.

At the same time, the past forty years split the Germans in regard to the way they dealt with the Nazi period. The East German state resembled the Nazi regime both in its overall appearance and in its political makeup, while it simultaneously

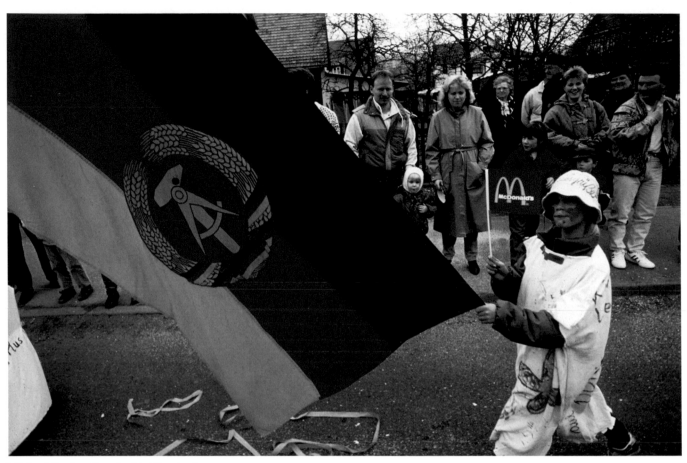

Michael Engler, *Carnival in Thuringia*, 1990

prevented any questions about the German past. West Germany, in contrast, witnessed the return of street violence—one of the seminal experiences of the Weimar Republic (between the wars). There were brutal conflicts between demonstrators and policemen, especially in Berlin and Frankfurt, and then the urban guerrillas emerged. With the latter, societal violence turned into media violence—West Germany could not have been more western.

A crucial moment in West Germany's self-questioning came in 1977, with the kidnapping and murder of Hanns Martin Schleyer, chairman of the German Employers Association. This kidnapping was one of the numerous operations carried out by the RAF, the Red Army Faction, as the group around Andreas Baader and Ulrike Meinhof called itself. That was the autumn that became known as the "German Autumn." Earlier, in May 1976, Meinhof had been found hanged in her Stuttgart prison cell, during the long trial of the first RAF generation. In spring 1977, the remaining three defendants were sentenced to life imprisonment. Schleyer was to be freed in exchange for the release of these three and some of their convicted comrades. But the West German government sacrificed Schleyer, whose corpse was found in the trunk of a green Audi more than six weeks after the abduction.

The RAF had emerged from the extreme wing of the poli-

ticized students. As far back as her student days in the late 1950s, Meinhof had already protested against nuclear arms for West Germany. However, it was the Vietnam War that finally radicalized her and sent her underground in 1970. This was the first war to be followed on TV, and for the generation born during World War II (Baader) or before it (Meinhof), the remote Asian conflict proved how incapable the Germans were of dealing with their moral obligations. This responsibility—which, as the "special German responsibility" has since entered the rhetoric of even the conservatives—can be construed as follows: After six years of an aggressive and annihilatory war against other European nations, after the ruthless, machinelike, bureaucratically organized extermination of Jews, Communists, Social Democrats, gypsies, homosexuals, and mentally retarded (to name just the main victims of the Holocaust), the Germans must be responsible for and committed to justice and must defend it more quickly than other nations. This expectation is based on the idea that a crime can be at least partially atoned for through moral integrity. Instead, several of these children of the Third Reich observed that full bellies and modest prosperity had brought a dulling of minds, helping to cement the amnesia about the Nazi past. In order for their fathers to get angry at America about the war in Vietnam, they would have first had to settle accounts with themselves.

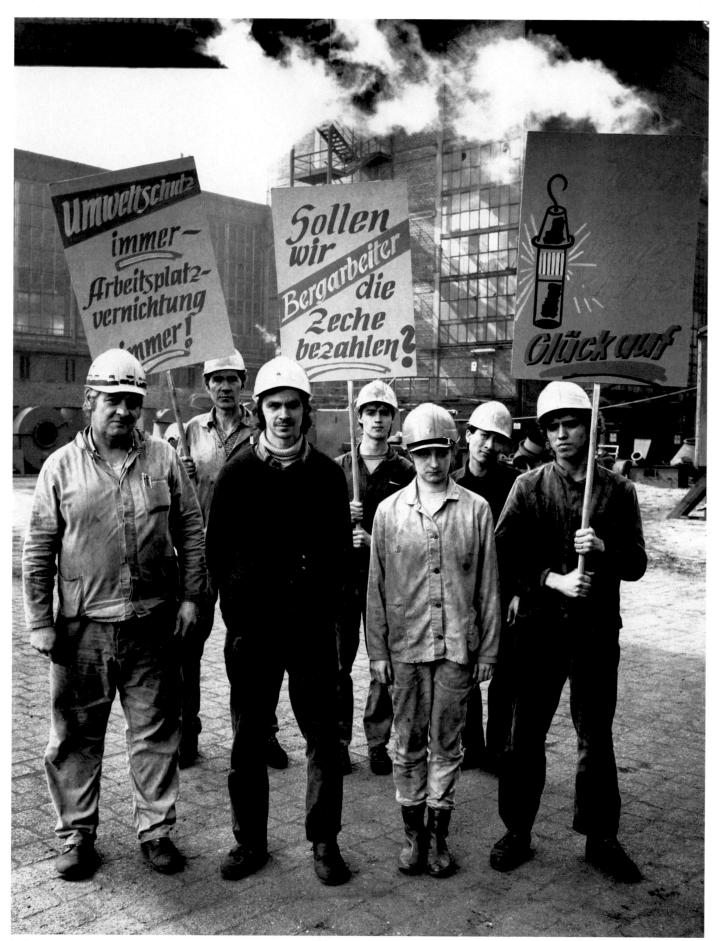

Stefan Moses, *Strikers, East Germany*, 1990

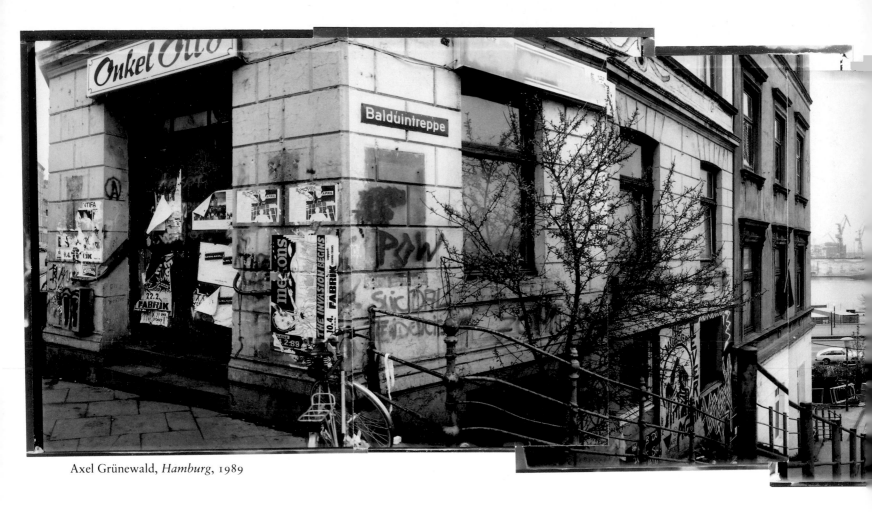

Axel Grünewald, *Hamburg*, 1989

But it was the grown children who did the settling. And they brooked no excuses.

The members of the first RAF generation became the magazine heroes of the early 1970s. *Stern*, a leading illustrated magazine, achieved its greatest flowering with the RAF. These "terrorists" had names and faces; they were idealists; their lonesome struggle was construed, and feared, as deriving from a much broader context. In fall 1977, after the hijacking of a Lufthansa plane failed to attain the desired goal of freeing the prisoners, Baader, Gudrun Ensslin, and Jan-Carl Raspe were found dead in their cells. Their deaths became a trauma for Bonn, which was unable to fully wipe out the suspicion that West Germany had simply liquidated its errant offspring.

With the deaths of Schleyer and the prisoners, the meaningful core of the militarized revolt began to dissolve. Schleyer was the ideal victim for self-appointed German city guerrillas—especially because he embodied postwar Germany's continuity with the Third Reich: Schleyer had been a member of the SS.

Three Mercedes-Benzes were found at the scene of Schleyer's abduction. One was Schleyer's, the second that of the people accompanying him. The third was used by the kidnappers to intercept Schleyer's convoy. It was almost ironic of them to drive a Mercedes in order to carry out the kidnapping: for the RAF normally preferred (stolen) BMWs, Porsches, and Alfa Romeos, the cars of lawyers, dentists, and business consul-

tants. After all, not only did the RAF incarnate the dogma of the fight against the "military-industrial complex," but its fighters appeared to be bohemians, free spirits, anarchists. They never drove a Mercedes, much less an Opel (a General Motors subsidiary). The Mercedes was a token of success, but also inflexibility, a status symbol for people who had lost all enthusiasm—the vehicle of the affluent and the would-be affluent, the petty bourgeoisie.

Talking about the "petty bourgeoisie" is one of the obsessions of the German bourgeoisie. The petty bourgeois, an artisan or a skilled worker, is satisfied with his acquired comforts; he settles in with his crocheted doilies and flower pictures and has no interest in literature or society. But, as the German bourgeoisie has been claiming for decades, the petty bourgeoisie was responsible for Hitler. This is a projection, of course, for the professors and physicians, the teachers and pastors, the judges and artists also lent a hand in bringing Hitler to power. But blaming others is convenient. One can pass the buck without citing Marxist class conflicts, merely by appealing to something that would appear self-evident.

The RAF conceived of its fight as a struggle between elites, BMW vs. Mercedes. The RAF never planted bombs in train stations. West Germans thus knew that there was scant likelihood of their ever falling victim to this conflict. So it made no difference whether a Göttingen student wrote under a pseud-

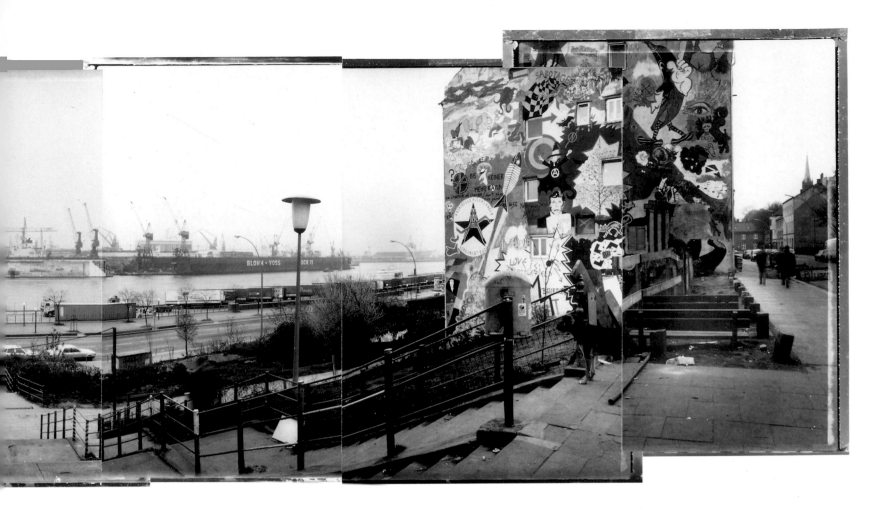

onym that he (or she) secretly rejoiced at Schleyer's death, or angry burghers demanded the restoration of capital punishment (which had been abolished in 1945): the RAF brought home the distant war, as a vicarious battle. The postwar generation was able to hear their fathers come out with the "kill them" jargon of the Nazis. Even among the youth that did not identify with the self-styled urban guerrillas, the effect—the end of a masquerade—was noted with cynical satisfaction. The RAF presence was transmitted almost exclusively by photographs: wanted photos, shots of crime scenes, or the picture of Schleyer, who had to pose as an "RAF prisoner" in front of a banner with a five-pointed star and a machine gun on it. In contrast, the syntactically scrambled, highly ideological texts of the RAF were generally inaccessible and seldom registered beyond the closest surroundings of the RAF.

Naturally, the history of West Germany can be traced through other images as well: a radio reporter's euphoria when West Germany became the world soccer champion in 1954; the fatness of Ludwig Erhard, the minister of the economic miracle; the perfectionistic and coldly ornamental faces of the rebuilt cities; the fierce battles between demonstrators and policemen at nuclear plants; the unsuccessful mass peace demonstrations against Helmut Schmidt's nuclear armaments. However, the images of the German Autumn of 1977 embody the recurrence of things that had been repressed, but that did

not return in their familiar form. After all, the RAF was not an offspring of anti-Nazi resistance, nor, for all its brutality, could it be confused with the SS, the thugs of the Third Reich. Still, the RAF's attacks constituted a blitzkrieg against the fathers, against the overall functioning of West Germany, against the acceptance of Allied domination, against the power of commodity over mind. The RAF illustrated the finality of the generation gap, which became the ultimate societal experience of West Germany. The ability to live with the guilt for the Third Reich but not deny it had become the greatest challenge of West German society (until the surprise opening of East Germany). All "German traditions" prior to Hitler—Bismarck, Hegel, Beethoven, Goethe, Luther—had paled; they were impotent against the profound fissure that the question of guilt had driven into West Germany's postwar society.

These conflicts did not emerge anywhere near as vehemently in the far more closed society of East Germany. West Germany was the legal successor to the Third Reich (and as such is still paying reparations to Israel), while East Germany viewed itself as a new socialist entity, unhampered by the curses of the past. The Nazi era was handed down to school children in dogmatic Marxist rhetoric. The younger generation was to have no inkling that their own fathers might have been passive or active Nazis. At present, East Germany is finally undergoing an experience comparable to the West German conflict of the 1960s.

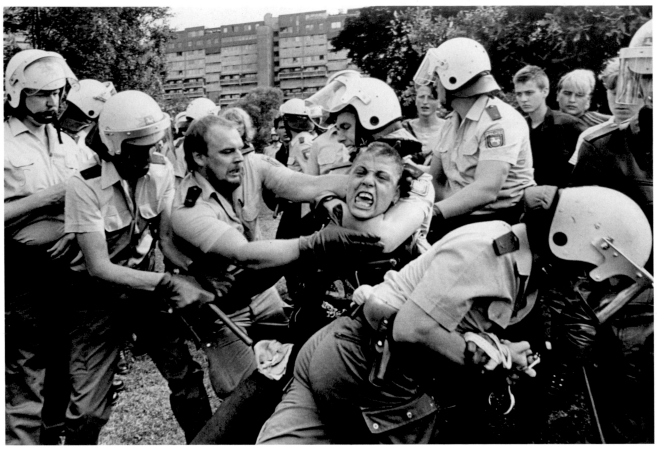

Martin Langer, *Chaostag Hannover* (Day of chaos, Hanover), 1984

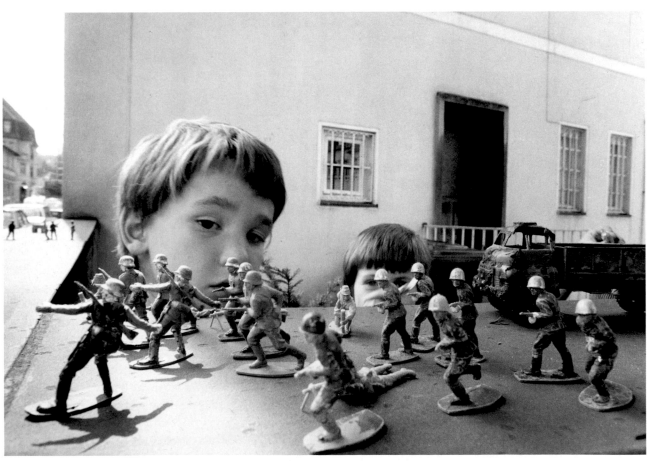

Hermine Oberück, *Child with War Toys*, 1982

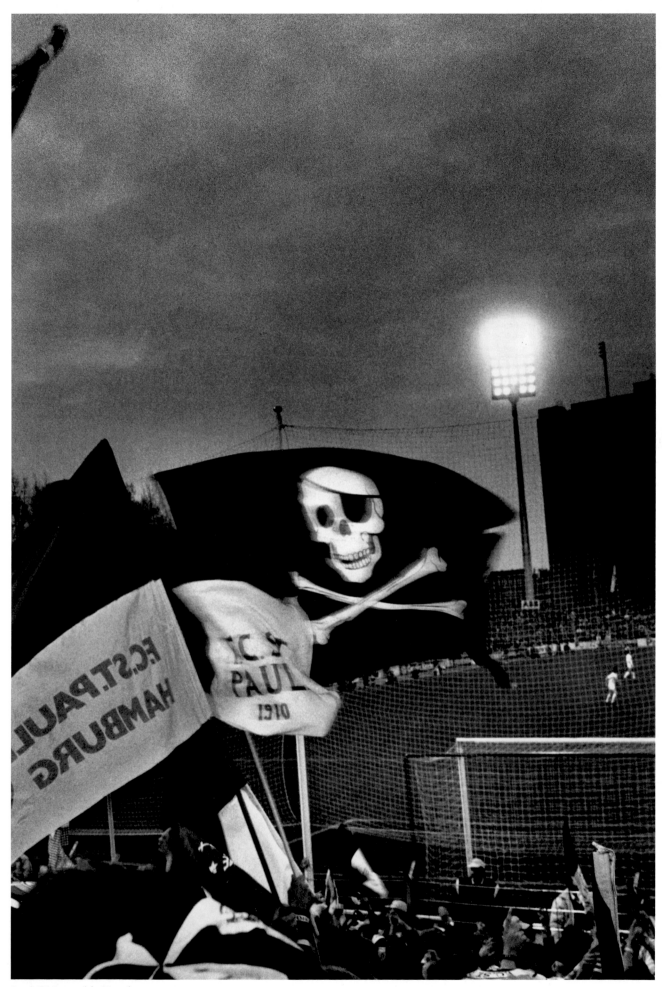

Axel Grünewald, *Hamburg*, 1989

21

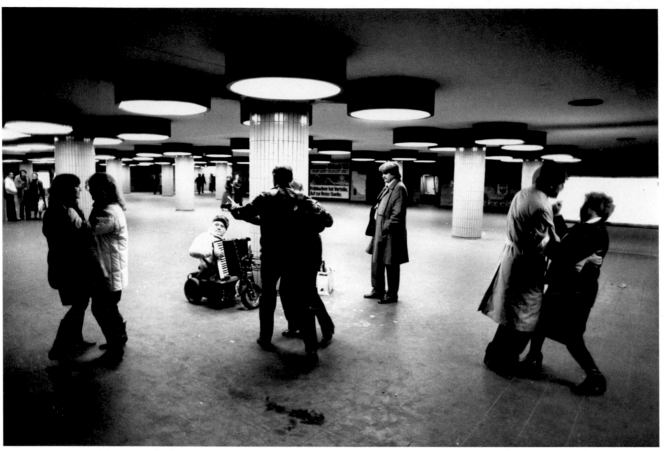

Robert Lebeck, *Dancers in Pedestrian Underpass, Berlin,* 1983

André Gelpke, *East Berlin,* 1983

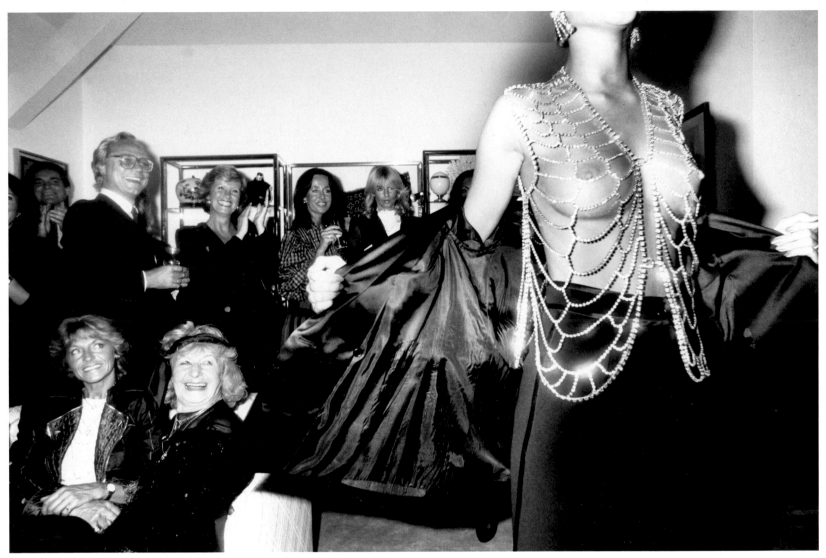

Herlinde Koelbl, *Private Fashion Show, Munich*, 1982

The question now is who to blame for the repressive everyday life of socialism. It is almost too late for the GDR to come to terms with the Nazi past. The war ended forty-five years ago.

While the "peaceful revolution" in Leipzig, Dresden, and East Berlin during fall 1989 was observed by the West Germans with almost universal sympathy, the citizens of the small socialist Germany have come increasingly to be viewed with skepticism. Within just a few months, the East German heroes turned into a consumption-crazed petty bourgeoisie, inundating the dynamic West with their ludicrous, nauseatingly smelly cars.

More surprising than the reports on the apparatus of the omnipotent party and the ubiquitous secret service was the discovery that prominent "terrorists" of the German Autumn had settled in the GDR years earlier. It was only when their neighbors and colleagues could finally travel that they found

those long-familiar faces on West German wanted posters. In the course of the arrests, *Stern* ran photos from the private lives of the ex-guerrillas, showing the once-cool children of the bourgeois elite in the perfect Babbittry of the everyday socialist routine.

This retrospectively altered the image of the "terrorists," whom no one had believed capable of returning from their bloodlust to the bliss of marriage and Wednesday-night bowling. The ex-RAFers practically assumed the function of models: with faces known to the West Germans for years, they terrifyingly demonstrated that the orderly socialist state knew only one brand of self-realization, and this one had all the attributes of the petty bourgeoisie. They were precisely the sort of people with whom you wouldn't care to be seen under the Eiffel Tower.

The RAF, incidentally, is still murdering away, coldly and anonymously. Its latest victim was Alfred Herrhausen, chairman of the board of Deutsche Bank: his car was blown up by a remote-controlled bomb. Yet strangely enough, the photos of the crime scene were neither penetrating nor widely circulated. By now, the RAF is good for only a minor shiver during the evening news; it no longer evokes collective fantasies.

In the German Autumn of 1977, West Germany, with the RAF, had reached the limits of its capacity to comprehend the Nazi era and use its understanding to improve conditions. Before and after 1968, most German citizens were unwilling to swear off the concept of social success based on economic growth and armaments. Few Germans cared to admit that, in terms of logistics, the Americans were waging their Vietnam war partially from military bases in West Germany.

On the other hand, the scar of guilt—in regard to the Nazi era—had burst open in the 1960s. Considerable portions of West German society have learned that it is better to keep this wound clean than to close it forcefully. There are various approaches to dealing with this guilt. Some people merely offer claptrap; some absorb small measures of new knowledge about the SS-state—whatever they can digest; some masochistically bathe in the deep pond of German terror. The images of the German Autumn of 1977 stand for the social limits of West Germany. Those Germans who, as I write, will soon no longer be East Germans will have little or no share in those memories. The West Germans may perhaps take advantage of this opportunity to snuff out all recollection of the recurrence of violence in 1977, the mise-en-scène of the war as a vicarious war.

In 1949, the two German states were founded pell-mell. That same year, Erich Kästner published his children's book, *Das doppelte Lottchen* (The double Lottchen). It tells the story of two adolescent girls, Lotte and Luise, who happen to meet in a holiday home. Initially astonished by their striking resemblance to one another, the two girls soon discover that they are actually twins, separated as infants during a divorce. The girls decide to bring their parents together again, and they succeed.

These two characters (and the mythical tale of separation and reunion) suggest the two Germanys. Lotte, who has grown up in straitened circumstances, has become earnest and severe, while Luise, having been rather spoiled, is sunny and somewhat loud. At the end of their vacations, the girls change roles, thereby surreptitiously getting to know each other's situation. In Kästner's book it is the slightly overexcited Luise who comforts the underprivileged Lotte. Most West Germans, though, have had trouble seeing people from the East as belonging to the family. The East Germans, who saw the introduction of the Western Deutsche Mark as the utmost good luck, in the months following have had to submit to a process which is called reunification, but in fact is so close to colonization that it's hard to find a better word for it. ☐

Translated from German by Joachim Neugroschel.

Dirk Reinartz, *Underpass, Duisberg,* 1986

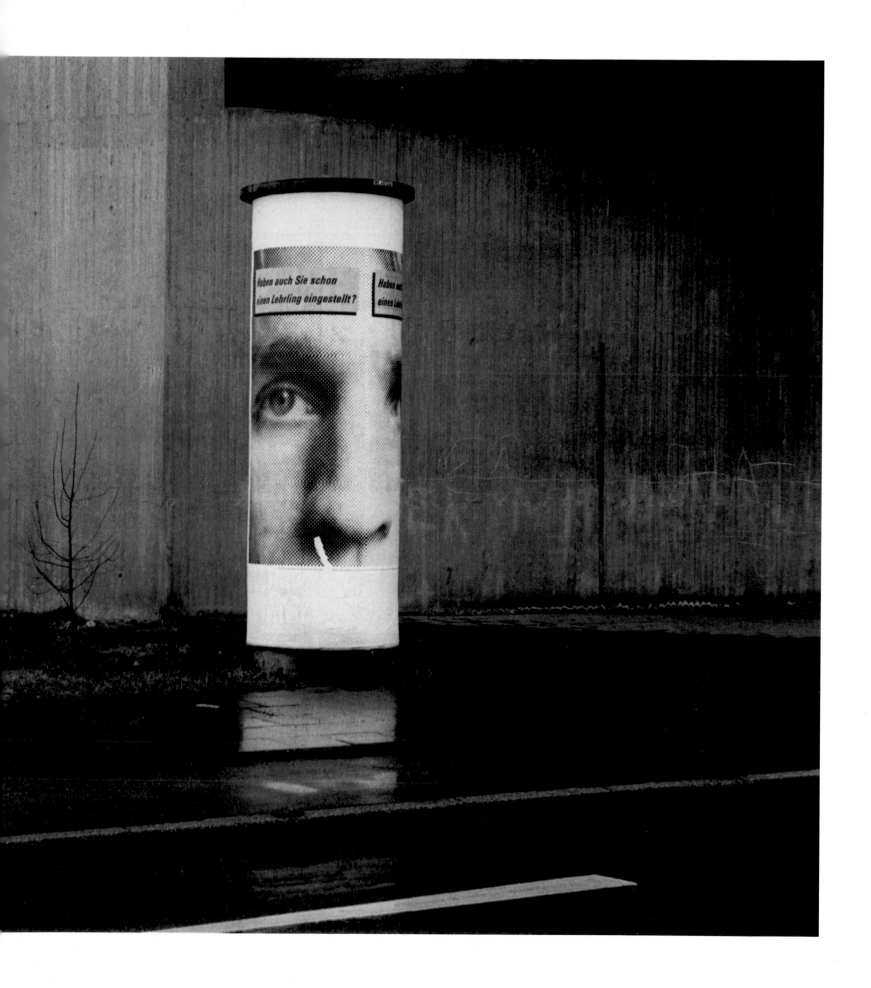

A View from the Temple:
The Photographs of Herbert List

By Max Scheler

In the late 1920s and early '30s Hamburg was second only to Berlin as an artistic center in Germany; a leading figure in the city's art scene was the son of a Hamburg coffee merchant, Herbert List. In 1929 Stephen Spender came to Hamburg to see the new liberal Germany; in his novel *The Temple*, Spender describes meeting List and the circle of young people around him. In that period List was becoming increasingly interested in photography. His first impetus to take photographs was simply to take pictures of his friends; later he began to use his friends as models for things he had in his mind—he put them in masks, posed them in costumes, set up tableaux at the beach. He also began to photograph surrealistic still lifes at this time.

List didn't like the coffee business, and didn't like Hamburg—for political reasons, but also for personal reasons: he was homosexual, which was difficult in those days. Finally in 1935 he moved to Paris to photograph. List's pictures were published in a few magazines, among them *Arts et Metiers Graphiques* and *Photographie*; he tried fashion photography, but it apparently didn't interest him much, as only a few examples survive.

In 1936 List visited Greece and was so impressed that he moved there the following year. For the next few years he divided his time between Paris and Greece. When Germany invaded Greece in 1941 he returned to Germany and settled in Munich. List made few photographs during the war. He had difficulties because he was of Jewish blood—he was only a quarter Jewish, but that was enough to taint you.

In 1944 he was drafted and stationed in Norway, where he worked in a map studio. At the end of the war he settled again in Munich and began to photograph for various magazines, including *Heute, Epoca*, and others. He made many books, among them a collection of his pictures from Greece, *Licht über Hellas* (Light over Hellas), and a book on Naples that he made with the filmmaker Vittorio DeSica. In the late 1950s List made many portraits of artists and writers throughout Europe. At that time he was considered the top magazine photographer in Germany. Occasionally his old photographs would be published here and there, in quality magazines.

More and more, though, he became involved in collecting drawings, mainly Italian master drawings. Finally in the early '60s he gave up photography altogether and devoted most of his time and energy to his drawing collection, which by the end of his life had become quite significant.

List was never really a professional photographer, but was in the best sense an amateur. He was well educated in literature and the arts, but he always had doubts about whether photography was an art. For him photography was a reflection of himself, and of the way he lived his life. □

26

Herbert List, *Baltic Sea*, 1934

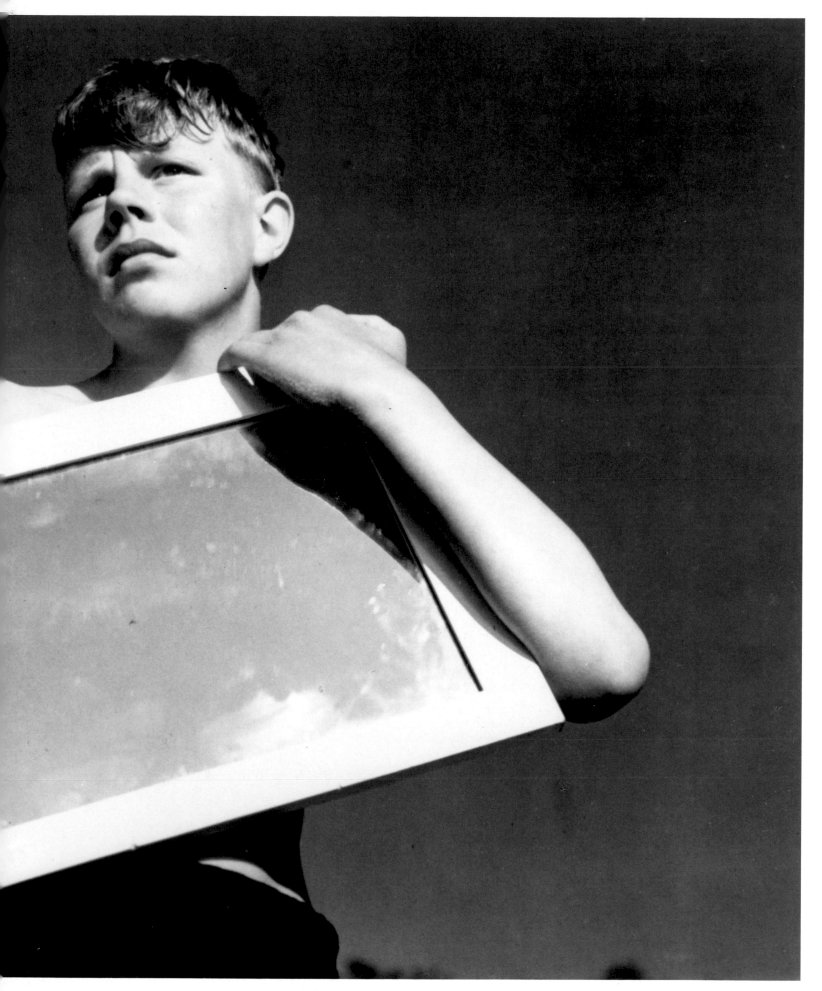

Herbert List, *Marina*, *Pireaus*, no date

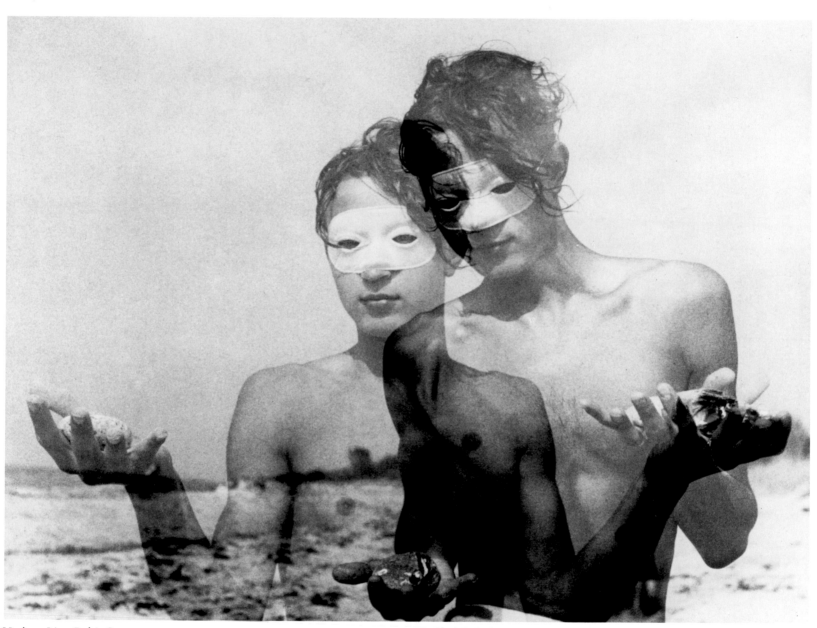

Herbert List, *Baltic Sea*, 1933

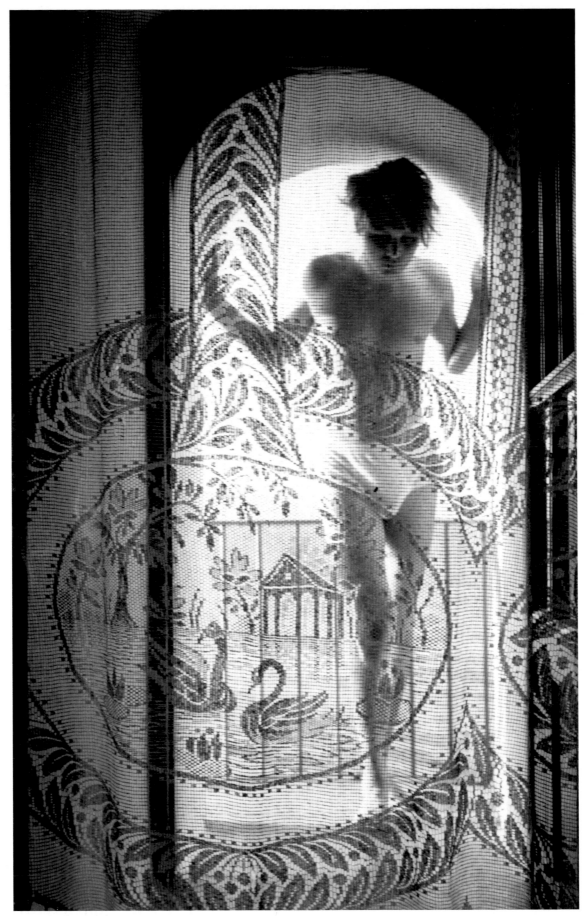

Herbert List, *Athens,* 1936

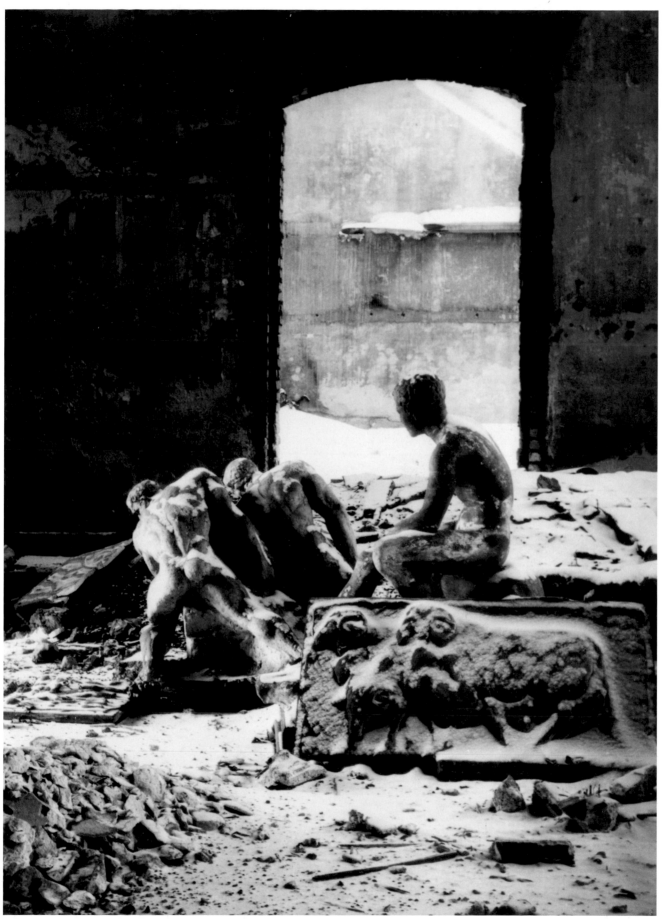

Herbert List, *Academy of Art, Munich*, 1945–46

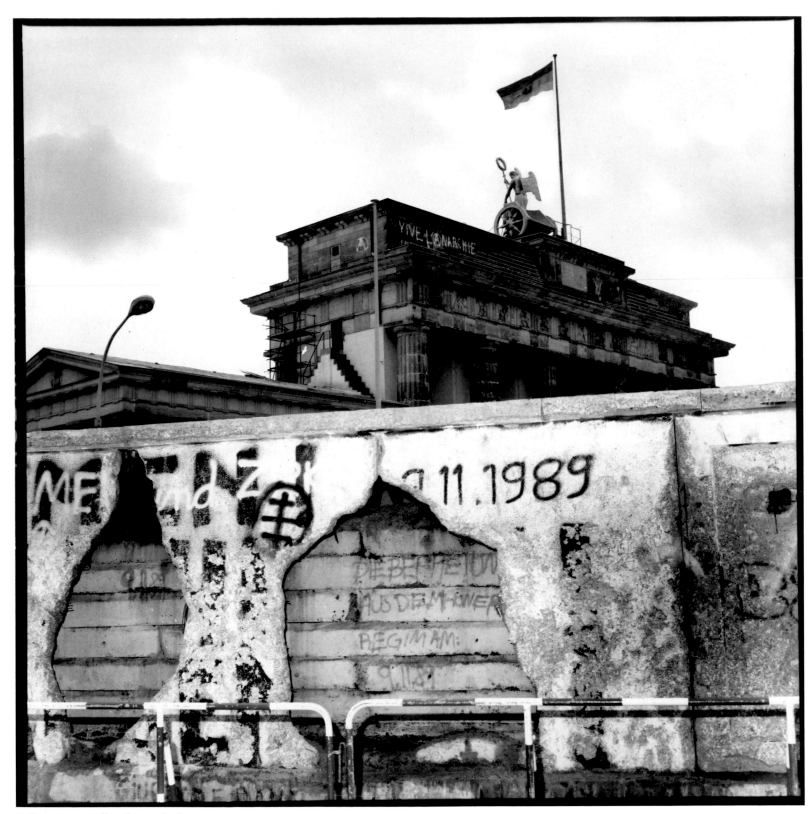

Volker Hinz, *Wall and Brandenburg Gate*, 1990

East Side, West Side: Berlin Between Euphoria and Anxiety

By Dieter Hildebrandt

Long the eastern outpost of the Cold War West, Berlin became a thriving center for avant-garde art and photography. With reunification and the collapse of the Wall, the city will change—for better or worse.

Berlin is well on its way to being once again the Hauptstadt, *the capital city, of a newly reunited Germany. But as Dieter Hildebrandt writes in the following essay, many Berliners regard that likelihood with mixed emotions. Berlin in the Golden '20s was the throbbing center of a remarkably rich cultural and artistic scene—a scene whose more extreme manifestations were captured by Christopher Isherwood in his* Berlin Stories. *But with the rise of the Nazis Berlin became the heart of the Third Reich, and as such suffered horrific destruction during the war. In the divided society of postwar Germany, though, Berlin took on a new character, that of cultural outpost, neither part of the economically thriving West nor the rigidly socialist East. Instead it offered a kind of haven for outsiders, and was the scene of a remarkable flowering of the arts—in part funded by a German government eager to help keep the city alive.*

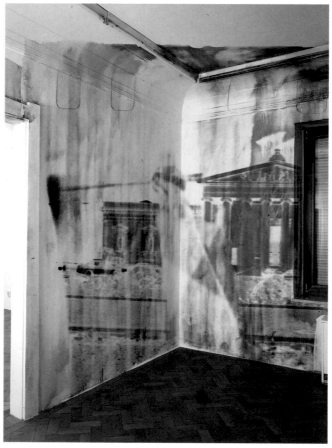

Ulrich Görlich, *Untitled, Munich* (installation in the Kunstraum, Munich), 1988

The pictures in this section reflect the dual role that Berlin has played over the past forty years—as a city whose status as the nominal capital of Germany is written into the Bundesrepublik's constitution, but also a cultural outpost. Works by Ulrich Görlich, Caroline Dlugos, and Gosbert Adler reflect the rich artistic scene of Berlin, while pictures by Volker Hinz, Gundula Schulze, Angela Neuke, and Gerhard Ullmann depict the dramatic events of the past year in Berlin and elsewhere, as the Wall has at last come down, and reunification has brought both celebration and uncertainty.—Editors

A symbolic experience: a couple of days ago when I was driving out of Berlin en route to Munich, I felt a strong sense of triumph as I whizzed past the former East German checkpoints, where, in the old days, we often had to wait for up to an hour. The barracks of the border police are still intact, and so are the small conveyor belts that used to roll the ID cards and

passports to the invisible officers of East Germany's State Security. But now these leftovers look like backdrops for a movie that's been moldering in the can far too long and hasn't got a prayer of ever making it into the theaters. I've saved an hour of waiting. . . . Berlin is no longer an isolated city. . . . You can drive freely to anywhere in Europe. . . . Those were more or less my thoughts as I zoomed along.

My sense of triumph was abortive. For after a short spell, my rush—in both senses of the word—was curtailed: I wound up stuck in permanent stop-and-go traffic. The time I had saved at the old checkpoints was soon used up by the countless traffic jams. It was a Sunday, and it seemed as if every car owner wanted to take advantage of the new freedom to travel. Three hundred miles of autobahn from Berlin to the south became one long parking lot. Too much traffic—and it was all bumper to bumper. My next thought: too much freedom, and no one can benefit from it.

My experience was symbolic, because it fitted in with the political situation of the new Berlin. Never before has the city been so free, and never before has it been so confined. Berlin is almost as united as in the past, and yet never has it been so split up. Its old communication and transportation possibilities have been restored, and yet it is on the verge of being left behind by the tumult of competing interests. The East-is-East-and-West-is-West story that defined a divided Berlin for over four decades is about to have a sequel. And everyone's wondering what it's going to be like. Boom town or shantytown? Germany's megalopolis or its poor house? Seat of government or merely an outpost maintained for prestige reasons?

"Mr. Gorbachev, tear this Wall down!" A grandstanding Ronald Reagan shouted those words at the Soviet Union's party boss and head of state; standing on a platform in front of the

Gosbert Adler, from the series "*Das Wort wird Fleisch und frisst mich*" (The word becomes flesh and devours me), 1988; left: *#10*; right: *#13*

Brandenburg Gate, the American president was speaking to the Berliners, to the entire world, and to his own electorate. The occasion was a city jubilee: Berlin was 750 years old. Two years later the unbelievable happened: Gorbachev contributed decisively to the collapse of the Wall. His visit to Berlin in early October 1989, his outspokenness among the East Berlin party princes, his ironic glances and laconic one-liners, shook the East German regime so thoroughly that the Wall opened up almost spontaneously on November 9, 1989.

By then, however, the Wall was something other than a mere barricade. Its western side had become the longest strip of graffiti in the world, a running fence of the imagination, a panoramic vision for artists and dilettantes. And an endless attraction for photographers from all over the world. The comic muse had also gotten hold of the monstrous and anachronistic concrete wall. This wasn't the Wall, this was the Rostock autobahn hung out to dry. That was one of the many jokes that Berlin's popular humor had come up with.

Meanwhile, the Wall has crumbled. Twelve percent of all Germans have taken home a scrap or a shred of this, the most modern of all antiques. However, the more interesting pieces are now to be found in the salons and castles of the wealthy, in exclusive galleries and avant-garde museums. You can find the Wall in Ronald Reagan's home and in the Vatican garden, in the house of a businessman in Phoenix, Arizona, and at Westminster College in Fulton, Missouri, where Churchill supposedly coined the term "Iron Curtain."

The worldwide interest in the "anti-Fascistic protection wall" is so vast that Berlin should have long since begun fencing off a couple of feet of the Wall *in situ*, to save it from total destruction and to preserve it as a historic document, a historical formation—like ancient Roman city walls or Greek temple streets or Minoan palaces: a *forum berolinum* coming from a brief, bad past and heading toward a future that is even more uncertain, although more suspenseful, than may be apparent amid the reunification euphoria. Now more than ever, people in both reunited parts are asking: What's to become of us?

These questions can also be read in people's faces. The status quo, you see, was a cemented balance, in which each half had its special function: West Berlin as the showcase of the West, an island of freedom, a demonstration of the democratic way of life, an outpost of the Free World, a PR agency of parliamentarianism; East Berlin as the capital of the German Democratic Republic, the parade ground of bureaucratic socialism, the demo model of the central planning system, the parlor in the crumbling house of the GDR. For decades, both parts of the city had been exhibition models of their respective systems, and they seemed downright predestined for the job. Berlin already had not only two railroad junctions, Ostkreuz and Westkreuz, but also two central areas since the 1920s: a historic old Prussian one in the eastern portion and a modern, elegant, efficient one along the axis of the Kurfürstendamm in the western portion.

However, the dramatic—and photogenic—aspect of the current situation is as follows. Not only has the Wall come tumbling down, but so have the strutting and blustering of confrontation, the duel of two global systems, the showdown of two ideologies. The Berliners—even if they wanted to be—are

no longer representatives or prototypes of the eastern and the western worlds. They now wander through the old vast areas of their city, going astray, getting stuck (not only in traffic), or experiencing the adventures of a new dimension.

A quick backward glance at the recent history of the city may help to clear up a few questions and anxieties. For Berlin has always been a city of paradoxes, seeming incompatibilities, and nonstop conflicts. January 1991 marked an anniversary: 120 years earlier, the Prussian residence had promoted Berlin to the capital of Germany. The Prussian king became emperor of a Germany that he didn't like (because it watered down the elitist notion of Prussia) and that didn't like him (because it was scared of his chancellor, Bismarck). And in this imperial Berlin, there was a yawning gap between two worlds. The gigantic construction boom of the "Gründerzeit," the period of rapid industrial expansion, 1871–73, contrasted with the indescribable poverty of Berlin's proletariat. Wilhelm II's military parades were attacked in Gerhart Hauptmann's critical plays, and the colossal historical canvasses in the official museums were contravened by, say, Edvard Munch's avant-garde *The Scream*, 1893. One year before the outbreak of World War I, a man who was intimate with the city wrote: "Berlin is doomed to keep becoming and never to be." Berlin, at that time, was already a tension-fraught work in progress.

The contrasts intensified after World War I. For one thing, Berlin could previously be taken in at a glance; now it turned into a megalopolis: in 1920 its suburbs—eight smaller towns and some sixty hamlets—became part of the city. This administrative act resulted in a Berlin of four million people. And the Golden '20s were launched: a time of cabarets and naked reviews, when intellectual highlife replaced military arrogance, glamour superseded glory. But that "golden" decade was also the period of massive inflation, the period of dreadful economic misery and epidemic unemployment. Strikes, putsches, political assassinations, and police brutality were the order of the day, while the evening brought the biggest entertainment that Berlin had ever witnessed. And then the Nazis broke into this conflict-ridden situation—at first not much more than a political Al Capone gang kicking up a rumpus.

In 1927, Berlin was still laughing at the strange nationalist neurotics. But six years later the Nazis usurped power, and the critical spirit of the city was broken. Germany's leading intellectuals were driven out or locked up or silenced. Most of the works devoured in the great book burning of May 10, 1933, were by authors who had lived and written in Berlin. The Golden '20s yielded to the brown '30s and then the bloody '40s.

The year 1945 brought a new beginning—but in a city that no longer existed. Berlin was a pile of ruins, at best a utopia. And even the ruins were divided, and the utopia split into two versions, East and West. Berlin became the urban setting of the Cold War. But the survivors had more important things to think about: food, heat, shelter. Any trees that the bombs had spared in the renowned Tiergarten park were chopped down by the Berliners during the icy winters. Yet the city was filled with a unique euphoria: plays were mounted everywhere. All of Berlin was a stage—to freely paraphrase Shakespeare.

Then all at once, Stalinism struck with the Berlin Blockade,

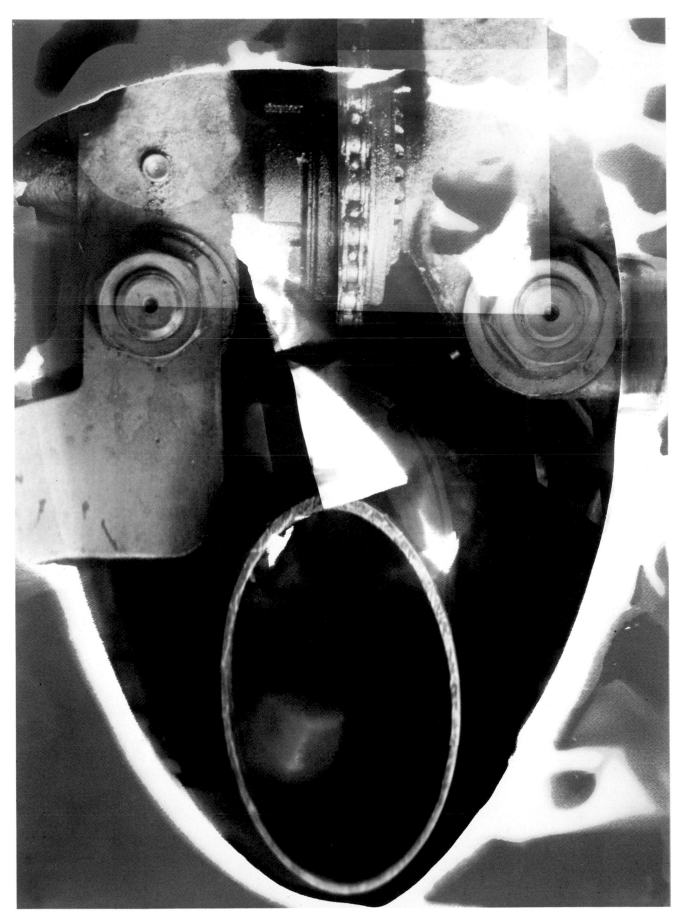

Caroline Dlugos, *Ekstase II, Portrait Fritz Lang* (Ecstasy II, Portrait Fritz Lang), 1988

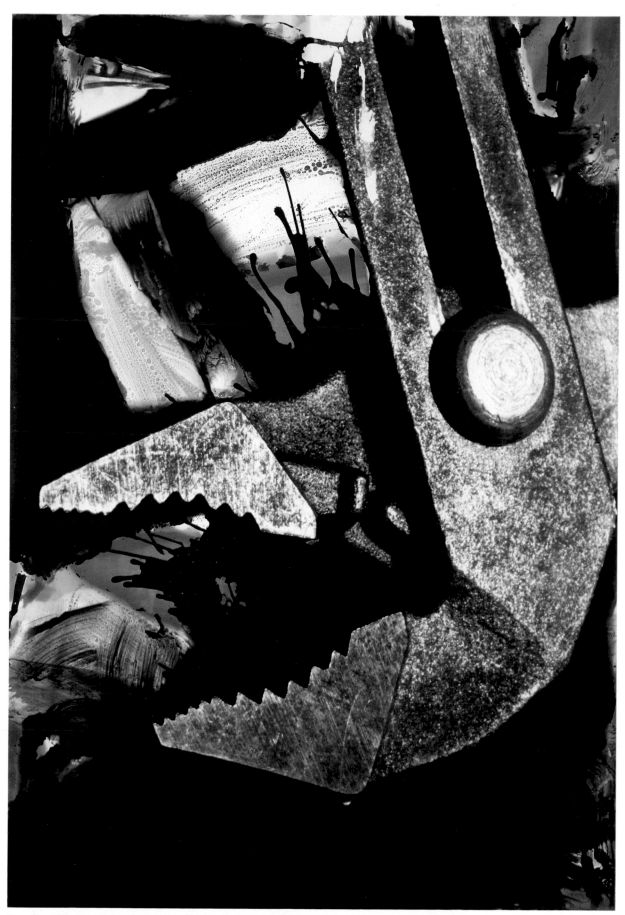

Caroline Dlugos, *Täuschung* (Simulation), 1988

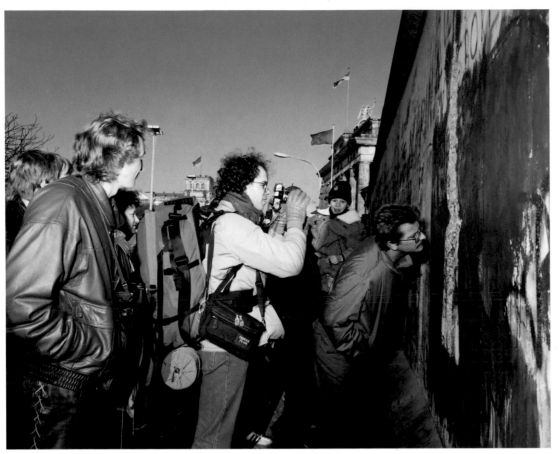

Angela Neuke, *Berlin*, 1989

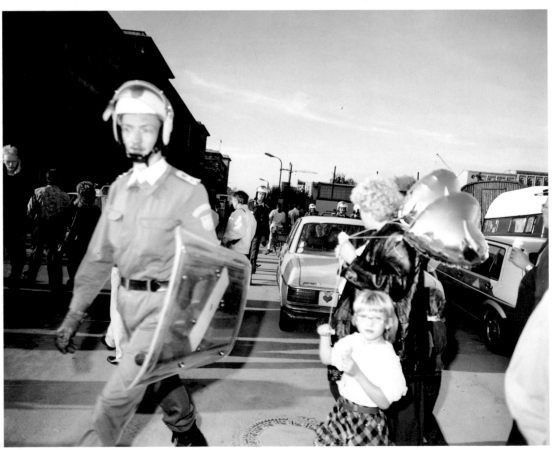

Angela Neuke, *Alexanderplatz, Unification Day, October 3*, 1990

Gundula Schulze, *Dresden*, 1989–90

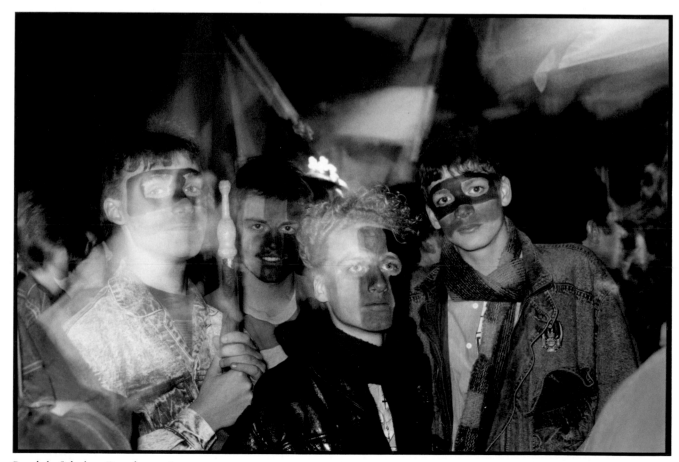

Gundula Schulze, *Dresden*, 1989–90

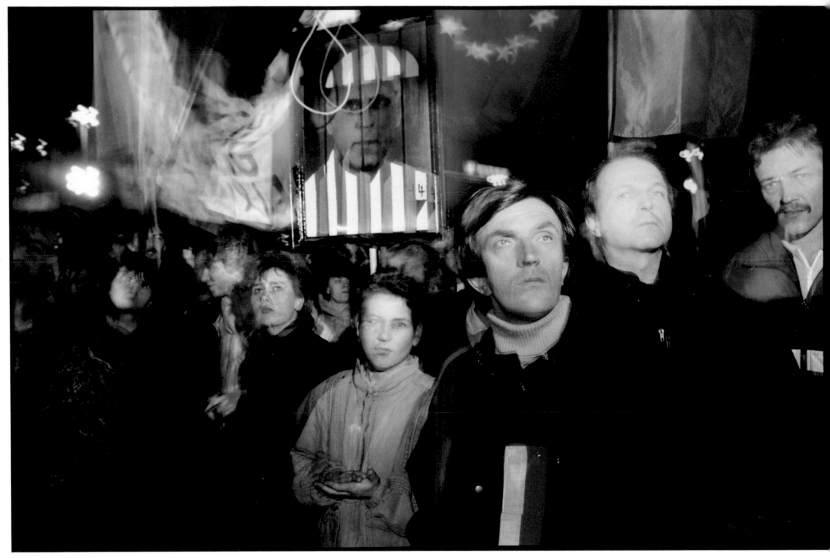

Gundula Schulze, *Dresden*, 1989–90

the West responded with the airlift, and then came the drama that can be summed up in a permanent headline: The Berlin Crisis. On August 13, 1961, the Wall definitively separated the two parts of the city, but not—one could state somewhat grandiloquently—the hearts of the Berliners. Berlin was considered a down-to-earth city, but it had a certain flair for the melodramatic. That was why President Kennedy's statement, "*Ich bin ein Berliner*," could cause such a sensation. In the difficult days of 1963, those words were a spiritual lifesaver for the people of Berlin.

And now? A grand future or a petty one? A bombastic future or a lamentable one? Will big business take over the city or will it be crushed by the thousand problems of the former GDR? Or both? Will the gap between East and West now turn into a socioeconomic conflict between high and low, old and new, rich and poor? Will the German government come to Berlin or will there be nothing but empty rhetoric? Will the Olympic Games be held here in the year 2000 or will new subsidy programs have to be implemented before then?

It is not the literati, not the playwrights, not the singers who can expose the full gamut of feelings. This is the job of the photographers, whose hour has struck. They are helping to express the vast subjectivity of this city: the fear and resignation, the confidence and elegance, the contradiction and jubilation, which in the days when the Wall was opened could be reduced to a single word: "Madness!" □

Translated from German by Joachim Neugroschel.

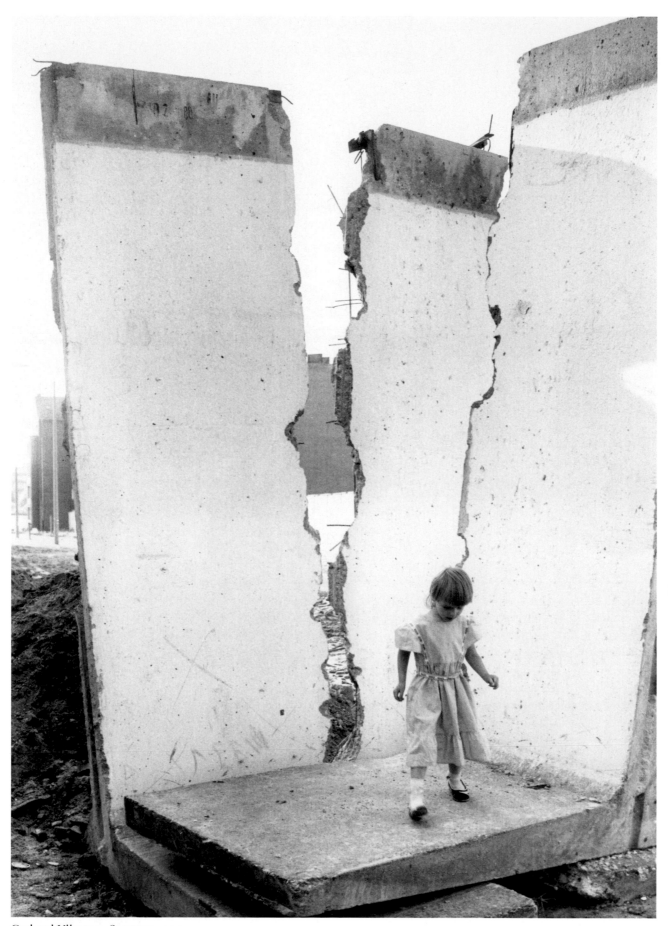

Gerhard Ullmann, *Summer 1990*

Another Country

By Christoph Tannert

Ute Mahler, *Prof. Heinrich Taut*, from the series "*Männerporträts*" (Portraits of men), 1987

A look back on the brief and unhappy history of the German Democratic Republic, better known as East Germany, and the difficulties of photographers who worked under it.

Events in what was the German Democratic Republic, or East Germany, are occurring so rapidly that there is little time to pause and reflect on their meaning. And yet the new Germany desperately needs such a breather. East Germans, emerging into the world from their national ghetto, have suddenly been pushed into social and democratic adulthood. Meanwhile, the East German economy is on the verge of collapse. As a result, xenophobia, misogyny, anti-intellectualism, and political extremism have found a new public in the East.

Since the unification, Germany has become a bit more northern and a bit more eastern. However, the added territory is distinctly provincial, a fact that will no doubt have a retarding effect on the cultural scene in West Germany. The energy for change that drove the East Germans a year ago has dissipated. East Germans today are proving to be excruciatingly normal.

The history of East German photography has yet to be written. For a brief thirty years, photography in the GDR meant chiefly press photography and photojournalism. After 1949, the start of the GDR's "Socialist restructuring," photography was most often used to provide an uncritical image that supported the apparatus of power. Until the end of the 1970s press photography was dominated by pictures of unproblematic subjects, and the staging of a varnished everyday reality.

Photography played a central role in the mass avoidance of reality that marked life in the East.

However, by the late 1950s, and even more so in the mid '60s, a tendency developed among some journalistic photographers to question the models assigned to them. This trend emphasized the individual photographic view, although it retained the reportage character of the pictorial language; among its adherents were the members of several groups, including Signum (Horst Sturm, Erich Schutt, Alfred Pazskowiak, Jochen Mollenschott, et al.), "action photography" (Evelyn Richter, Günter Rössler, Wolfgang G. Schröter, Renate and Roger Rössing), and DIREKT (Arno Fisher, Sibylle Bergemann, Roger Melis, Elisabeth Meinke, Brigitte Voigt, Michael Weidt). The cautious attempts of these groups to use photographs in magazines and newspapers to communicate rather than to indoctrinate was frustrated, mostly by the dogmatism of the editors of these publications. For the first time, professional photographers found themselves in an uncertain situation. Through their personal commitment they had challenged their status as obsequious suppliers of pictures, and now they had a chance to show their identity, their past and their future. The 1970s became a time of emancipation for a photography that was no longer oriented exclusively toward the press. For many photographers, this development also marked the beginning of a

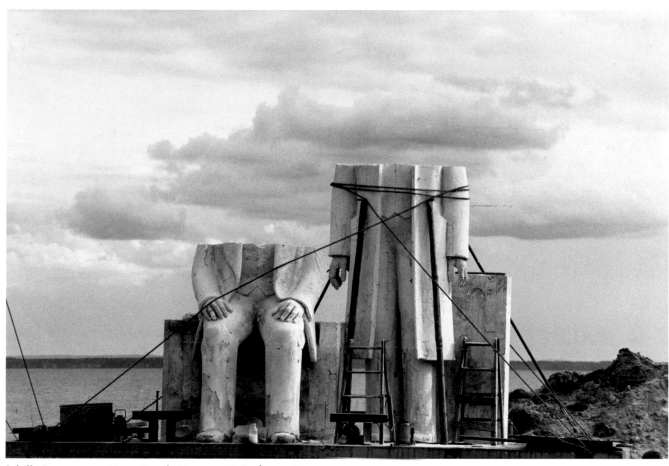

Sybille Bergemann, *Marx-Engels Monument, Berlin*, 1983

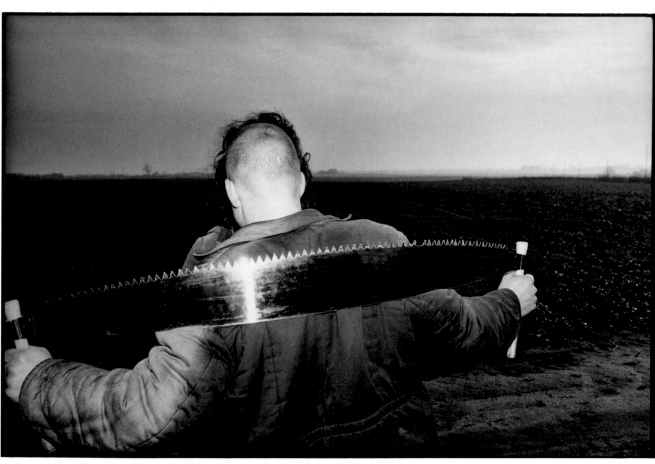

Stefan Nestler, *Portrait of Hendrik Silbermann*, 1988

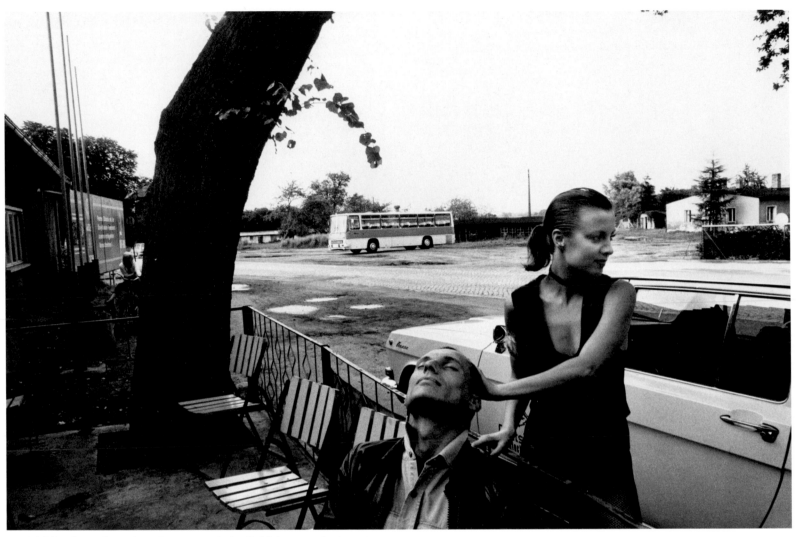

Ute Mahler, from the series "*Zusammen Leben*" (Living together), 1985

financially risky road, a situation that did not change until the end of the decade brought government subsidies (shows, grants, etc.) for art photographers.

A powerful social documentary tradition links the younger and older generations of East German photographers. The generation of the 1950s and 1960s has been followed by a younger group of photographers that includes Christiane Eisler, Jürgen Hohmuth, Thomas Kläber, Georg Krause, Gerdi Sippel, Renate Zeun, and others who have widened the paths of social documentation laid out years earlier.

In June 1990, at GALERIE vier, East Berlin's first private commercial gallery, Arno Fischer premiered his works from the 1950s: "raw and unusual pictures obsessed with details and everyday life," according to the critic Wolfgang Kil, who compared these photos to those of Robert Frank and René Burri. Fischer's works revealed the great impact he has had on subsequent GDR photographers, many of whom regard him as their

"master." This mentor/pupil relationship has not yet been documented, even in the GDR, just as other chapters of East German photography remain obscure. When Ulrich Domröse, a collector and historian of photography, presents his treasures from the early days of the GDR, certain opinions about the nature and value of work done since the War will have to be modified, and the photography of this country considered in an international context.

Even now, East German photography is dominated by narrative forms; only the generation of photographers born around 1950, among them Ulrich Wüst, Erasmus Schröter, and Florian Merkel, have had the courage to explore other directions. Today, reportage and documentation are alive and well; but now the youngsters—with installations, conceptual pieces, and medium-reflective questioning of reality—are coming into public awareness.

A few advocates of conceptual photography, chiefly artists,

Berlin, February 2, 1981 . . . *The list of people here who are going away keeps growing. Daily struggle for the ability to work, not to mention for "enjoyment." . . . We cannot hope that the used-up institutions, to which many were accustomed, will supply a new direction. Run a zigzag course. But there is no escape route in sight. . . .*

CHRISTA WOLF, *Cassandra*, 1983

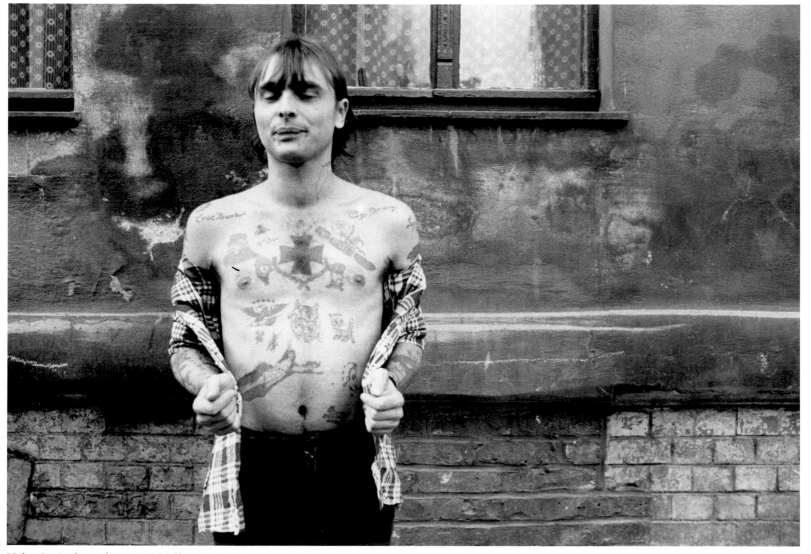

Helga Paris, from the series "Halle, 1984–85"

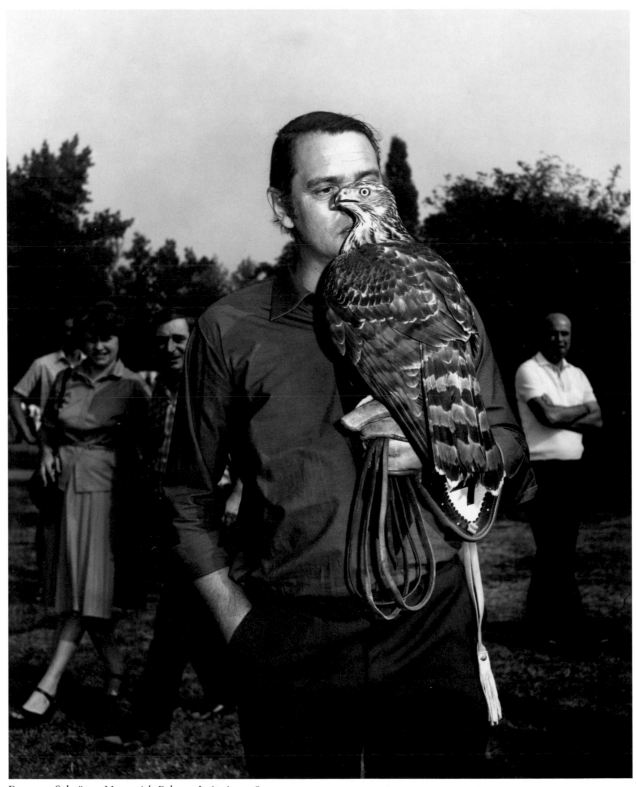

Erasmus Schröter, *Man with Falcon, Leipzig*, 1982

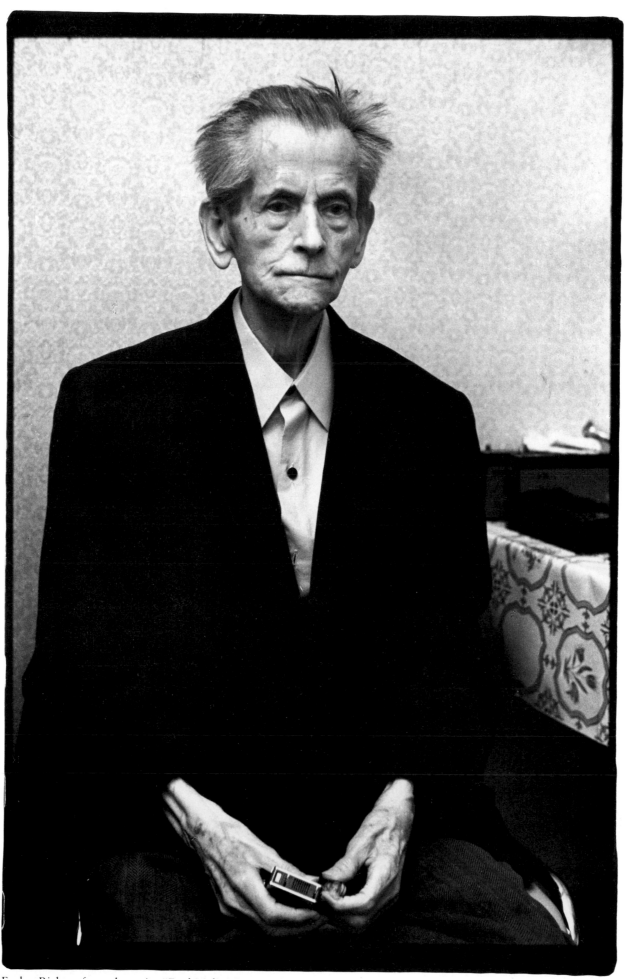

Evelyn Richter, from the series "Fred Malige," 1986

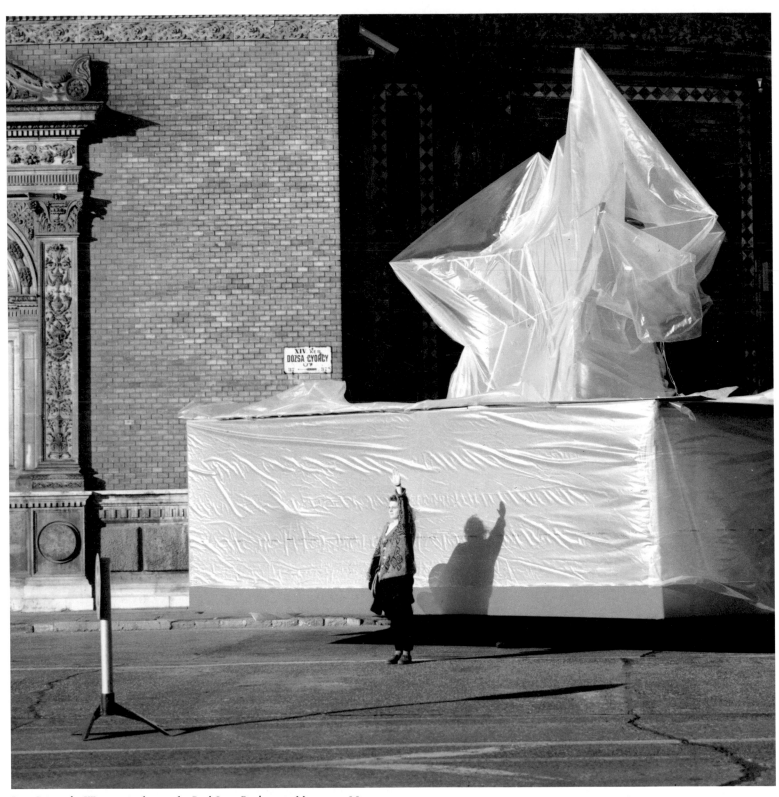

Jens Rötzsch, *Woman in front of a Red Star, Budapest, May 1, 1988*

have paved the way for this development. The photographer's body, his or her personal problems, besieged by decay and surrounded by the shards of civilization—these and other disparate themes have become the focus of a new interest. In Klaus Elle's work, existential feelings enter the pictures symbolically or through staged actions. Kurt Buchwald develops series of minute experiments in his performance-based efforts to track down a kind of essential photography; in 1990, Jörg Wähner and Buchwald undertook various anti-Stalinist protests, using conceptual means. Else Gabriel combines personal texts with photographs, seemingly without any logical connection, to produce an associative, sensual frame of reference.

Even after the opening of East Germany, its artists still remain marked by the "damage wrought by dictatorship." In the work of photographers who pursue more conventional forms, such as Jörg Knöfel, Peter Oehlmann, Tina Bara, Michael Scheffer, and Maria Sewcz, there is a conspicuous interest in the fragmentation of reality, expressed through pictures of details and angled shots. The works of these and other photographers make it clear that Eastern Europe is going through a profound and not always hopeful transformation.

Ursula Arnold, *View of the East through the Wall*, 1989

Jens Rötzsch develops a critical stance that confronts the viewer, especially in his pictures of political life before the "change," studying the mass jubilees and athletic events sponsored by the totalitarian social systems. Together with Peter Oehlmann he created an overview of East Germany with a provocative title: *"Protokoll Strecken"* (Protocol stretching). This exhibition, shown at the underground gallery EIGEN +ART (a pun meaning "one's own art" as well as "peculiarity"), promptly brought out the state security police.

Matthias Hoch, too, is an unerring observer with a strong sense of style. His commitment to photojournalism during the Leipzig Autumn has garnered recognition even beyond photography circles. The same is true of Uwe Fraudendorf; along with Ernst Goldberg, Frauendorf is one of the most important documentarians of Leipzig's counterculture, as well as a portraitist. In his 1990 project *"Real Mode"* (Real/fashion), Frauendorf presented a series about the lives of adolescents in the GDR— unspectacular but full of pleasure, frustration, and humor. Gundula Schulze's photos have always been controversial in

East Germany. Her nude portraits might have caused resentment if she had treated her models with voyeuristic sensationalism, but instead her pictures are gently ironic in depicting people without their social masks.

In discussing East German photography, it is important also to recall the many photographers who, under the pressure of constant regimentation, fled to the West before the Berlin Wall came down: among them Barbara Berthold, Markus Hawlik, Erasmus Schröter, Thomas Florschuetz, and the group called *"Nach uns die Zukunft"* (After us the future) (Leupold, Hentschel, and Leupold). Florschuetz, a native of Karl-Marx-Stadt, is a self-taught photographer whose first pictures were black-and-white portraits, presented in a 50 × 50 cm. format. Now, with his wall-sized compositions which pay homage to picture-within-a-picture photographs as well as to symbolic scenarios based on close-ups of the body, Florschuetz belongs in the first rank of young European photographers.

Nowadays, anyone writing about East Germany might do well to narrow his field of vision to the daily newspapers. Even weekly forecasts are likely to be contradicted by events. On October 3, 1990, the German Democratic Republic ceased to exist. I feel as if I were writing on burning paper. Yet the opening of the border to the West has brought momentum and change to East Germany's cultural scene. The artists' associations, which have been meeting to discuss the crisis, are now focusing on such issues as self-criticism and organizational reform. The Association of Fine Artists of the GDR, which before was a government tool for intimidating artists, has lost all influence and is on the verge of disbanding. New and independent artists' associations are already being formed. Art has shucked off its role as a safety valve and a surrogate reality for the public. With the dismantling of taboos between fall 1989 and fall 1990, provocative young artists found that they had lost their notoriety as martyrs; they have now had to develop a new conception of themselves, to get back to their work. The past twelve months have been difficult but exciting for East German photographers. Now this chapter has ended. Henceforth, individual artists will have to test their worth in the international arena. □

Translated from German by Joachim Neugroschel.

Memory's Quest

By Martin Walser

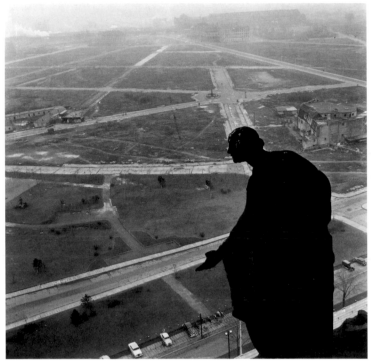

Hilmar Pabel, *Downtown Dresden, View from City Hall*, 1955

Memories of the destruction brought about by World War II remain vivid and painful for Germans. Novelist Martin Walser describes one man's attempt to reconstruct the memories recorded in his family photographs, lost in the firebombing of Dresden.

Memories of the Second World War and its terrible consequences retain an overwhelming importance for Germany today. In the following excerpt from his current work in progress, Die Verteidigung der Kindheit *(The defense of childhood), novelist Martin Walser presents the story of a young man whose family home was destroyed in the firebombing of Dresden in February 1945, and who for years afterwards attempts to reconstruct the family history that had been encapsulated in the photo albums and home movies incinerated in that horrible destruction.*

The photographers whose work is included here also rely on the memory of the war and its aftermath for their subjects: Hilmar Pabel directly, in his reportage photographs of the war and its destruction; Markus Hawlik, in his jux- *taposition of the steps of the Nuremberg stadium—the site of Nazism's most grandiose rallies—with the simple wooden cross of a fallen soldier; Elfi Fröhlich, in her large Cibachrome panels, depicting images from her childhood; and Clemens Mitscher, with his chemically altered print of an East German border guard peering across at the West. For these photographers, as for most Germans, the war remains a defining event, politically, economically, and morally.—Editors*

In late February 1953, he was not yet collecting any earlier sentences that cropped up. Photographs were still enough for him. This had begun after February 13, 1945, when the Dorn apartment at Borsbergstrasse 28d had burned up along with Dresden, and so had the family's photo albums, in which he himself had played the leading part. Three home movies had also burned up: "First Day of School," "Silver Anniversary." "Confirmation." He had also played the lead in at least two of these movies. And several streets further, on Kaulbachstrasse, his maternal grandparents had gone up in smoke. So what good does it do to gradually realize that you are concerned with the past? Alfred Dorn would never have dreamed that art could pinch-hit here. All he cared about was facts, nothing else. What he then did with facts is beyond the grasp of so-called common sense. If a man who is called stingy has died and you find half a million under his squalid mattress, what did he do with his money? He couldn't get enough of it. Alfred Dorn couldn't get enough of the past.

He also researched the old address directories at the National Library for his project on the past. In 1936, when he and his mother had vacationed in Reit in Winkl, they had stayed at the Edelweiss Hotel, where they had met a Frau Reinhardt, who ran a drugstore in Bautzen. He found the address in the old directories and wrote her there, asking—as he always did when seeking out his past— whether she had any photos left from those days. He instantly received a friendly reply explaining that her drugstore had been wiped out in the war, but not her home: she had found three photos and was enclosing them. Two of these photos are uninteresting, but the third shows a group of Edelweiss guests with Alfred and his mother outside the boarding house in August 1936, and both of them are wearing Tyrolean hats. The day on which these pictures arrived was a festive day, a day of jubilation. He could gaze at such pictures forever. Not that gazing at them helped him learn anything he didn't know about that vacation in 1936; such a photo simply had an inexhaustible effulgence for him. Mother and he in Tyrolean hats. These hats had burned up in that February night. Now he practically had them back.

The legendary Frau Reinhardt even gave him the address of a woman in Berlin who had stayed at the Edelweiss

Clemens Mitscher, from the series "Pictures from the Front," 1989

at that time. A Fräulein Gleihe. And she lived less than five minutes from the Moabit District Court. He spent two hours with Fräulein Gleihe, chatting about Reit in Winkl; he showed her the photo, in which she also appeared, and he asked her for the names of the other people in it. Fräulein Gleihe was past seventy, and her heart was set on visiting Reit in Winkl once again. All earlier times had been merely a preamble to the future trip. Alfred was traveling in the opposite direction. He had to know who had been photographed with him. What was the name of the large boy, who must have been ten years older than Alfred, towering above all the others and the only one who was barefoot—just what was his name!?

But all that this Fräulein Gleihe knew was that the Edelweiss had been run by a Frau Bachmaier. So he instantly contacted the mayor of Reit in Winkl, asking whether that was still the case: no, Frau Bachmaier moved on 10/26/36 to Munich, Widenmayerstrasse 47. Word from Munich: at this address, there has only been a *Herr* Bachmaier, who moved to Berlin in 1955. Finding a Bachmaier in Berlin would be a piece of cake. Maybe he could also dig up a photo that even he, Mr. Memory, as his mother called him, had forgotten. Nothing could be left to chance, much less to the hazards of association. The past can be unfolded only systematically. And there was nothing more important than or even roughly as important as unfolding the past.

A whole bookshelf of photo albums had been tended by both him and his mother until the night of the air raid. Some of the albums had pictures showing only Alfred; others had pictures of Mother, Father, and Alfred; still others, pictures of relatives and friends. And one album only had pictures of their ancestors. This album had had just a few thick, very stiff, dark-green pages. Father's gold bars, which he had managed to obtain as a dentist, had been taken along into the basement. Not the albums. Nor those three movies that had captured a wealth of details from the most important moments of his growing up. "The First Day of School," 1936; "Silver Anniversary," 1942; there he was, filmed, for instance, at the piano, playing his St. Christopher Legend. And

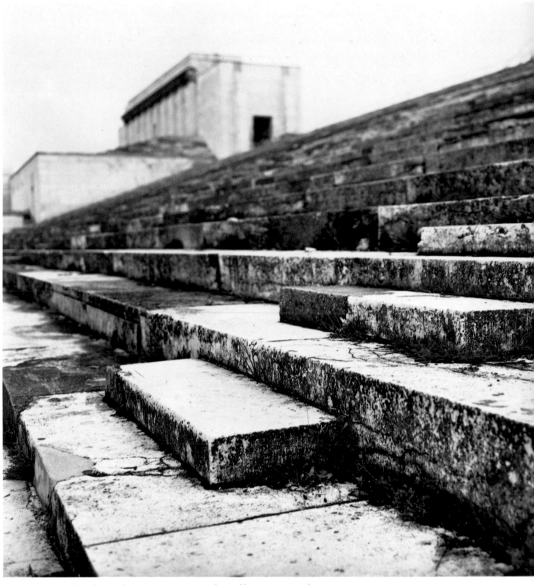

Markus Hawlik, from the series "*Normaler Alltag*" (Everyday occurrences), 1988

"Confirmation," Palm Sunday, 1944. The movies had been screened at every family celebration, and every single time his father had had the same trouble with the projector. Alfred, leaning against his mother in the dark room, had enjoyed hearing his father curse.

When Mother had packed the air-raid valise, she had been able to include only the barest essentials. And by this point, no one was expecting any further bombings. Mid February 1945! So far, Dresden had been virtually spared. After all, the war was almost over. Dresden was crowded with 500,000 women, children, soldiers, who had fled from the East. And now the city had been hit by three cunning, fabulously precise attacks in the space of twelve hours targeting

the heart of the city, the jewel of Old Dresden, which was not vital to the German war effort. If between one and two hundred thousand people have been killed, you don't complain about two dozen photo albums and three movies.

But nevertheless he wanted the pictures back. Anyone who had any contact with the Dorns knew that Alfred collected pictures of earlier days. Alfred sometimes claimed that he was gathering and arranging these pictures purely for his mother. He wanted to preserve the more beautiful times for her, their times together, in pictures that would fuse into a totality when she looked at them. But after his mother's death, he had not stopped collecting these pictures; quite the contrary: throughout his

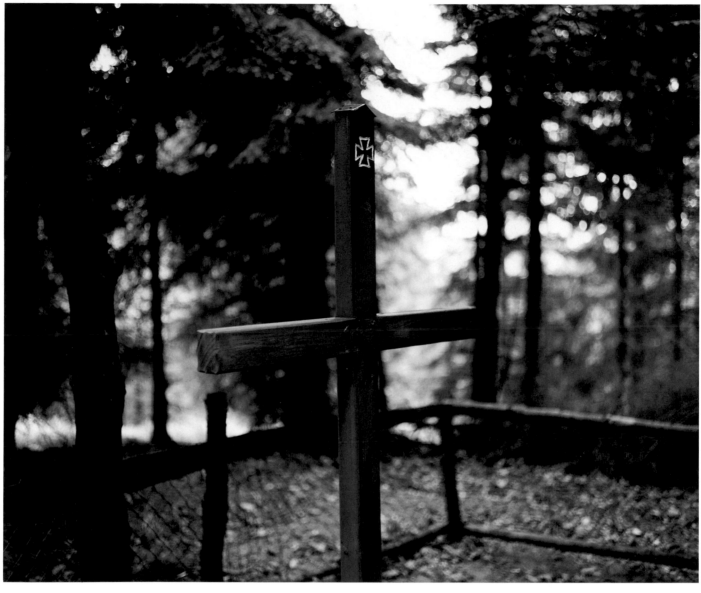

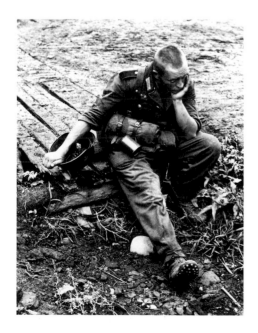

life, he had not devoted so much effort and energy to anything as he had to the gathering of such pictures.

Since he had been a child prodigy at the piano and always the undisputed head of his class, he had developed something like an aura. His mother was certainly the only priestess of this cult. But wherever his father happened to be, he would drop a word or two about his all-around marvelously gifted son, who was now studying law, music, and philosophy at Leipzig. The parents had twice commissioned sculptors to do Alfred's portrait. First for their silver anniversary, in 1942, and then once more in 1948, when he had brought home his

Hilmar Pabel, *German Soldier in Russia*, 1943

high-school diploma with that wonderful straight-A average. Alfred Dorn could not help thinking of himself as an important person.

Alfred's unremitting tendency to chase after vestiges of the past cannot be reduced to one single motive. In the summer of 1950, when his father left the apartment at Bauernbusch 22 forever, Alfred notified his mother's sister Marlene, who had been living in New York since 1922; after informing her of this fact, he wrote: Please do not pass any kind of judgment on these events.

An impossible demand. And yet it was willingly made in his name. Family circumstances and those of world history may have caused his propensity for preserving vestiges of the past to gain more

53

Elfi Fröhlich, *Inszenierung der Authentizität* (Staging of the authentic), 1989

Elfi Fröhlich, *Reflux* (Vomit), 1989

and more control of his mind. The present—for him, this was the compulsion to leave the past and turn to life. Life: that was an ensemble of tasks that he did not care for. The future, for him, was merely an unbearable continuation of the present—progressive disintegration, which he had always witnessed in his hair and teeth, his skin and bones, and which he now observed more and more closely and fearfully. This fear of decay could break out at any moment, the terror aroused by transience. Anxiety intensified into despair. There was nothing he could do. It was enough that Aunt Marlene wrote to him from New York, saying she didn't understand why he was so obstinately inconveniencing other people because of a few ancient photos! Why did she react so nastily? What had he done wrong in his letter? Since February 13, 1945! That was the day on which he always kept landing. He would

then often go on a crying jag, which made him feel like an infant. The air-raid signal, his refusal to get up, his mother's fear, his father's absence, Mardi Gras, Father with the other Martha at the Sarassani Circus, so he had to get up, catch Kauz, the tomcat that Frau Halbedl had brought, he couldn't catch it and bring it down to the basement—Father would have managed.

However, Alfred did not maintain this role. The first time the house was hit, he clung to his mother. In the following weeks and months, why hadn't he kept combing and digging through the charred ruins of the building? Perhaps the movies, the albums could have been saved. There would have been nothing more important than digging through the ruins of Borsbergstrasse 28d. And he had failed to do so. Because of Leipzig. Because of West Berlin. Because of his law studies. That was utterly grotesque.

The ruins of the house in which his grandparents had perished were cleared away, the whole of Kaulbachstrasse was razed; it would no longer exist on the new map of the city. And he had not photographed the final state of the ruins, the single and dreadful tomb of his grandparents. Nor had he photographed the ruins of the Ehrlich Institute. Then it was cleared. Torn away. Vanished. And his mother had gone to school there for years. Or the ruins of his school, the Kreuzschule. Father's friend Dr. Sattmann would have lent him his camera. Reluctantly, but he could not have turned the request down flatly. Because of a course of study that had nothing to do with him, Alfred had failed to do the only thing he considered important. For he would never become a lawyer. He would become nothing. Preferably nothing. □

Translated from German by Joachim Neugroschel.

The Mask of Opticality

By Enno Kaufhold

Exploiting the camera's ability to provide optically precise and apparently neutral records, an influential group of German artists are reworking such familiar genres as portraits, landscapes, and architectural photography.

Bernd and Hilla Becher, *Oil Refinery (details)*, 1988

Pictures do not explain themselves, and even if two are identical in form, it does not mean that they share the same intentions or content. Photographs are not excluded from this; those made with the greatest possible optical precision may have completely different contents or—since photographic technology can be used to produce pictures virtually automatically—may have no intended contents at all. Thus it is not always easy to distinguish between photographs that record in a purely mechanical manner and those that, guided by the human intellect, use photographic precision to show essential things. Hence, if something appears hidden behind the photographic mask of opticality, you can look into its true face only if you pull off this mask and peer behind it.

This is not a phenomenon peculiar to photography, but something philosophers have reflected upon for over two thousand years: the difference between what something appears to be, and what it actually is. For centuries, painters have discriminated between appearance and essence, and, to an extent, have attempted to paint essence in its appearance. With the invention of photography, technology for the first time made things appear without any apparent activity by intellect or handicraft. It is hardly surprising then that the most photographic of all photographs—optically precise, accurately detailed images—have been the ones most emphatically denied the claim to reproduce essence. Despite this, there has long been a tradition of "photographic" photography, with outstanding photographers in every country working in this style.

In Germany, Bernd and Hilla Becher, who began their photographic collaboration in 1959 (Bernd Becher had previously painted, while Hilla Becher had worked as a photographer) are an integral part of this tradition. In this they follow earlier photographers, among them Karl Blossfeldt, August Sander, and Albert Renger-Patzsch, whose work in the 1920s and '30s implied an ideal of photographic objectivity. When the Bechers began their systematic photographic studies of industry, though, the photography world was under the sway of the humanistic approach. Influenced by Edward Steichen's "The Family of Man" (1955), an exhibition that aimed at reconciling the world through photography, photographers tried to show humanity in all its aspects. Karl Pawek's book *Totale Photographie* (Total photography, 1960) supplied the theoretical basis for this photography, which was documented in several international exhibitions. This narrative, reportage-like photography, which aimed at depicting the universally human, exerted a massive influence in photography in the 1950s and '60s.

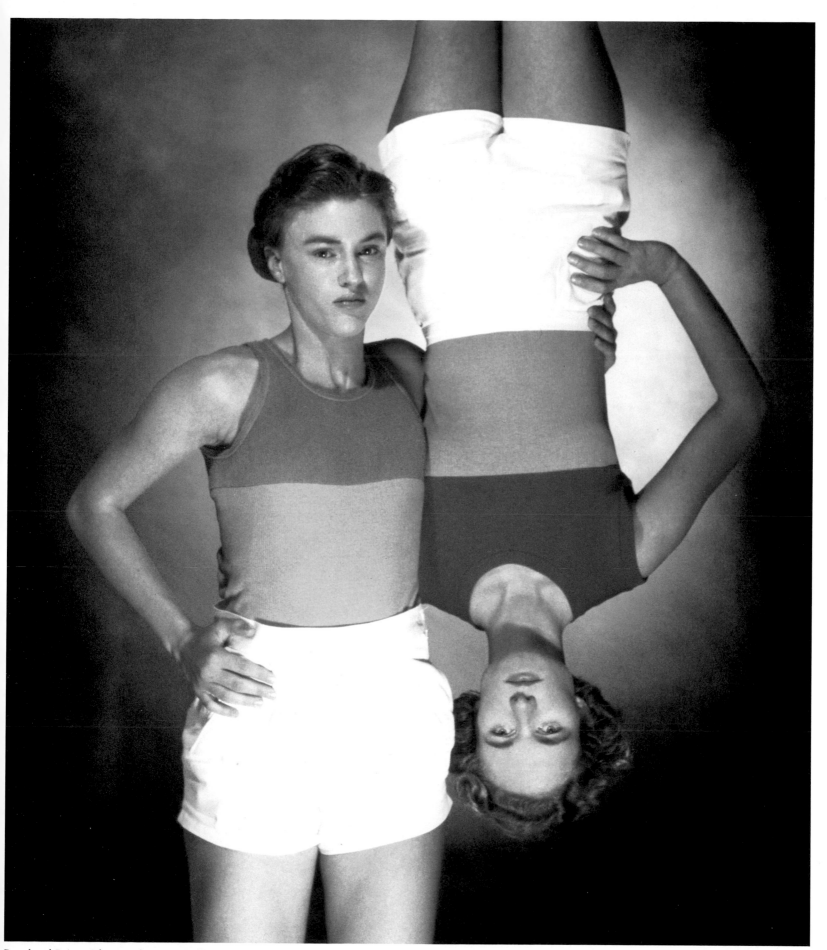

Bernhard Prinz, *Rhetorische Fragestellung* (Rhetorical question), 1988

Thomas Ruff, *Portrait*, 1988

Thomas Ruff, *Portrait*, 1988

By comparison, the Bechers, with their deserted and object-oriented industrial views, were working in out-of-the-way aesthetic territory. Nevertheless, over the years they continued to photograph all sorts of industrial structures: water towers, grain silos, gas containers, limekilns, pithead gears, blast furnaces, steel mills, coal bunkers, cooling towers, processing plants, and half-timbered houses. To find their subjects, the Bechers toured West Germany, Holland, France, Belgium, England, and the United States. Not only the photographic precision with which they depicted these scenes, but also the systematic and methodical nature of their project, corresponded to the new seeing that achieved prominence in the 1920s. Both Blossfeldt and Sander, for example, had already produced photographic series of plants or people.

Although nobody is actually working in any of the Bechers' photographs, their pictures nevertheless imply the presence of the laboring person. For human beings not only invaded nature through work, pushing it back with their industrial facilities; in a sense they also created themselves, through a dialectical process. Just as one can reconstruct the whole texture of a civilization from every stone in an ancient ruin, one can also reconstruct the life of modern society from the Bechers' views of industrial structures. And since many of these industrial facilities and objects no longer exist, it is from their photographs that future generations (for whom industrial archeology will be more than just a trendy term) will derive the dialectical process that has produced modern industrial society.

The distinctive form of the Bechers' photographs is due in part to the uniform lighting and systematic composition of each picture. The diffuse, almost unfocussed illumination, which rejects highlights and chiaroscuro effects, gives these photographs a consistent visual appearance, and gives each picture its magic charm. The overall form of the work also includes the conceptual factor of the series, the resolute line-up of pictures of similar kinds of industrial objects, seen always from the same point of view, and the typology of these objects that results. This is still evident today, when the Bechers have begun to present their prints in larger formats and to exhibit them individually, not just in groups.

The Bechers' systematic labor, which has been going on for almost three decades now, is unprecedented for both German and international photography. It has even spawned a school—in a very literal sense, since Bernd Becher has taught for many years at Düsseldorf's Kunstakademie, and several of his students, including Axel Hütte, Thomas Struth, Andreas Gursky, Candida Höfer, and Thomas Ruff, have made names for themselves internationally. However, it would be wrong to assume that these disciples are following directly in the path set out by their mentor. Not only is there a generation's difference in age (all these students were born during the 1950s), there has also

Bernhard Prinz, installation at the Kunstforum in the Grundkreditbank, Berlin, 1989. Background: *Clean Linen*, 1984–89. Foreground: *Untitled*, 1989, sculpture installation.

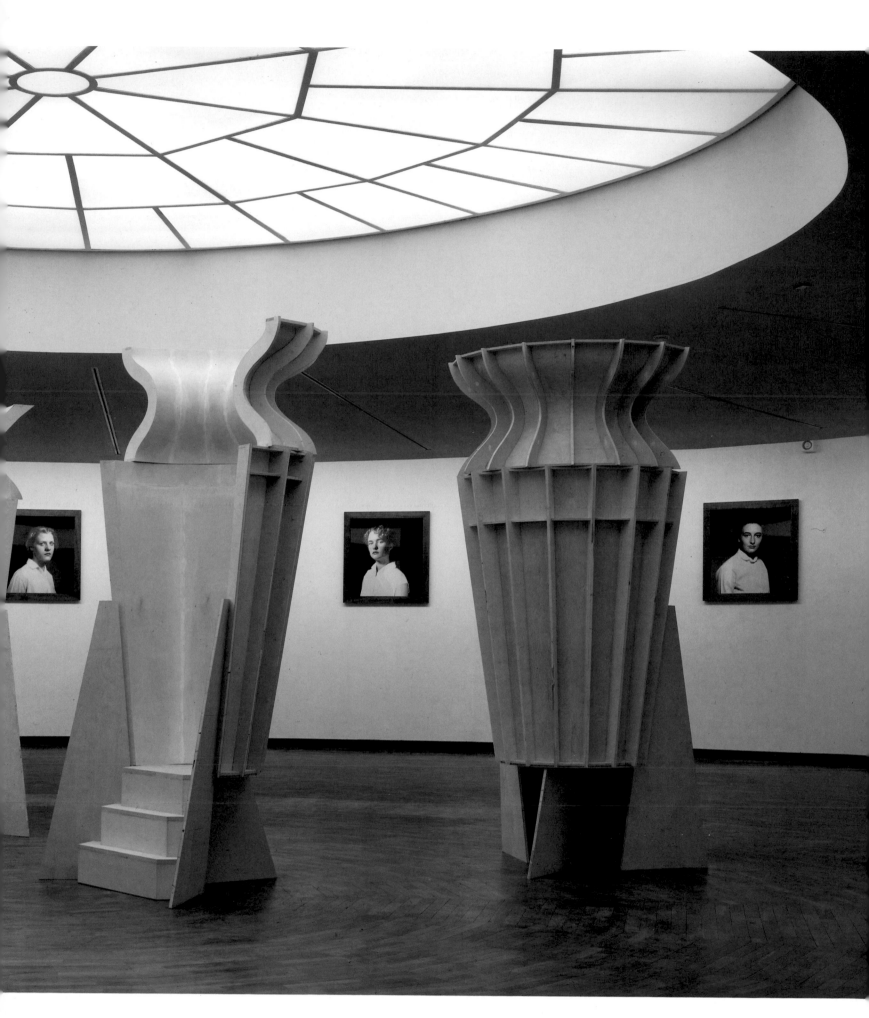

Axel Hütte, *Poggio II*, 1990

Thomas Ruff, *Häuser Nr. 121* (Houses, No. 121), 1988

Andreas Gursky, *Paris, Beaugrenelle,* 1988

Our intention is not to make aesthetically pleasing photographs but to make detailed illustrations which, because of the lack of photographic effects, become relatively objective.

We do not intend to make reliquaries out of old industrial buildings. What we would like is to produce a more or less perfect chain of different forms and shapes. . . .

BERND AND HILLA BECHER, *Kunst-Zeitung* (Düsseldorf), 1969

been a change of paradigm in their work, from pure photography to a self-conscious form of work which, sloughing off the rules of traditional photography, aims unmistakably at achieving the status of art.

The element that all the work shares is photographic precision; however, the intentions behind it vary. Each of Becher's pupils has chosen his or her own special precinct and found a distinct pictorial stamp; yet none of them resorts to the same absolute exclusivity and systematization as their teacher. Furthermore, the context they work in has changed. After the integration of photography into the international art market during the 1970s and especially the '80s, the Bechers' disciples managed to establish themselves in the art world very quickly. (The Bechers, of course, had made a name for themselves in the art world decades ago.)

Thus, Axel Hütte initially photographed the dreary, deserted staircases, basement apartments, and garage entrances of standardized postwar German architecture. Based on a central perspective and eschewing all special effects, his seemingly quiet views offered images of terror rather than harmony. Menace lurked behind every corbeling, every door. During the 1980s, though, Hütte, like many of his colleagues, switched to color photography. He did so both for aesthetic reasons and because of improved laboratory conditions. Moreover, new and more durable color paper made it possible to produce larger prints. Hütte's newer pieces have been made in Italy. Architecture is still part of the picture—not as the only subject, but as an element interlaced with nature. In Hütte's recent work the connections between historic walls and organic nature become visible.

As far back as 1979, Thomas Struth—no doubt with a glance toward his mentor—advocated "photographs without any personal signature." Like Hütte, he too launched into black-and-white architectural views. But although architecture dominated these pieces, Struth was interested neither in architectural photography in a conventional sense nor in the architect's style. Struth's goal was to depict the material side of contemporary urban reality with its different, disparate signs. In his pictures public space is presented as a modern jungle. In the course of the 1980s Struth took photographs in the most diverse big cities and suburbs. Whether in black and white or color, these photographs are distinguished by their optical precision and emphatically central perspective. Entitled "*Unbewusste Orte*" (Unconscious places), these pictures have been widely exhibited and published. Over the past few years, Struth has also made a series of portraits of families, which likewise aim at optical precision. Each family poses with extremely earnest faces, the members placed at the same distance from the camera (and from the photographer). In contrast to the city images, these group portraits have no spatial depth, a lack that underscores their serious and statuary character.

While for Hütte and Struth, as for the Bechers, human beings remain invisible or are only indirectly suggested in the pictures, Andreas Gursky includes human beings in his pictures of architecture and landscapes. But these figures are not a form of decor in the traditional sense; only marginal in the overall picture, they melt into the natural surroundings. In Gursky's series "*Sonntagsbilder*" (Sunday pictures) and other works, people are shown fishing, swimming, pursuing leisure activities. Yet their behavior is so restrained that it appears neither genrelike nor anecdotal. This reduction of activity is matched by the diffuse lighting, which, as in the Bechers' oeuvre, never varies.

Using the same lack of lighting effects and zooming in on individual faces with the blank stare of the camera, Thomas Ruff's portraits reveal the impact of the Bechers' work. For the past several years Ruff has photographed these portraits in a systematic way; as with the work of the Bechers, Ruff's portraits reveal a strong conceptual aspect. By no means can Ruff be considered a portraitist in the conventional sense. His sitters wear no makeup, so that their every facial blemish and dermatological flaw is clearly revealed; moreover, the mise-en-scène is starkly simple. The models are frontally lit, so that his pictures resemble ID-card pictures or photobooth images. Adding to the fascination of these portraits is the fact that Ruff presents them in huge blowups—up to ten feet tall—producing a stunning visual effect.

Given the deadpan, seemingly styleless nature of his pictures, it comes as no surprise that Ruff is put down as a bungler by some German photographers, concerned more with craft than with images; these photographers also rail against the fact that his pictures are sold as art, fetching high prices in the bargain. As a result, Ruff has been personally vilified and the art market per se has been defamed. This too is evidence, although circumstantial, of the gap between the work of the Becher disciples and pure photography.

An even clearer connection with art can be seen in the photographs of Günther Förg, whose work with the camera

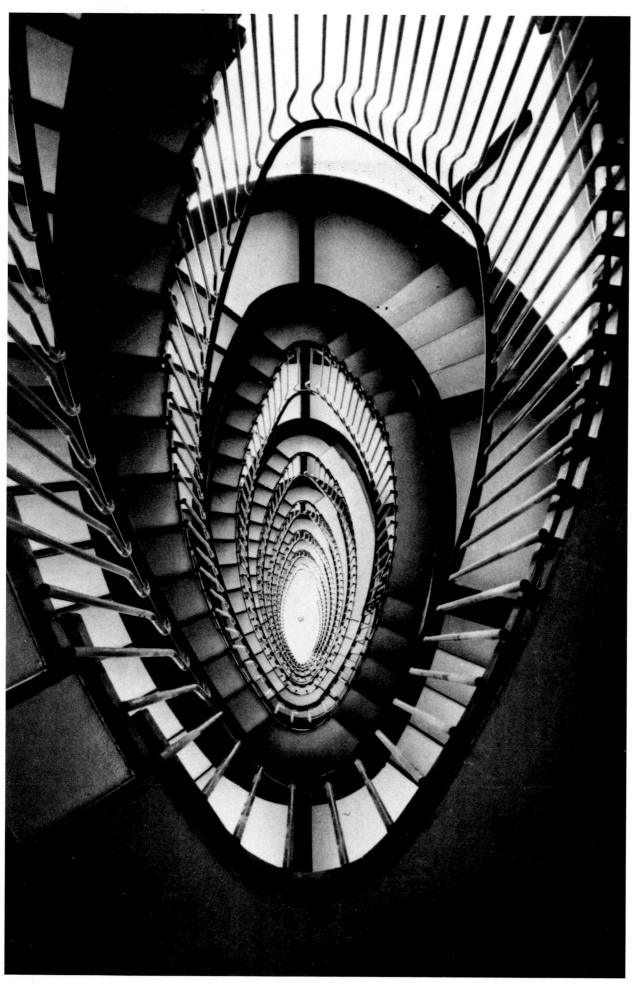

Günther Förg, *Staircase, Rome*, 1985

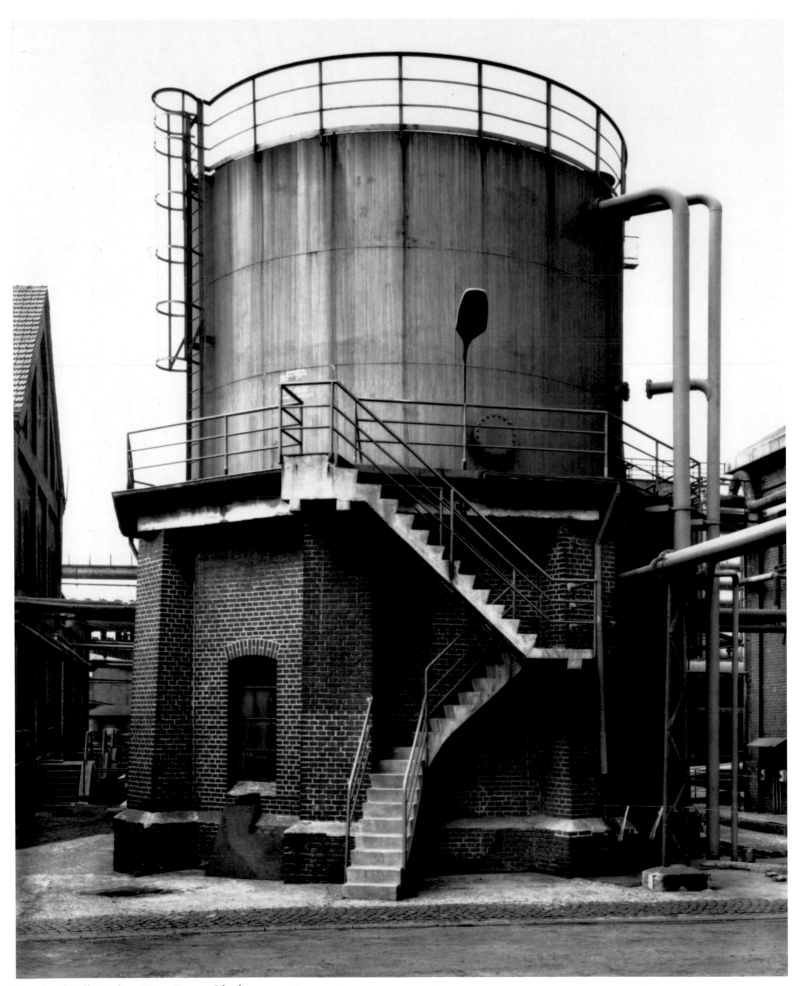

Bernd and Hilla Becher, *Water Tower, Oberhausen*, 1967

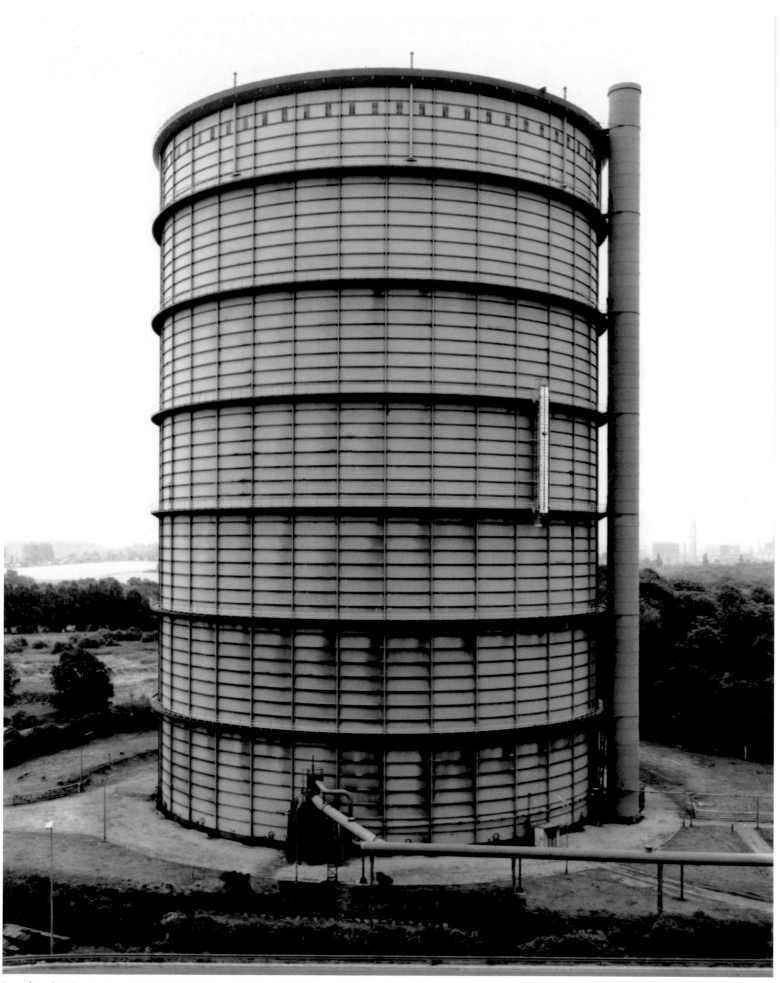

Bernd and Hilla Becher, *Gas Tank (Floating Ceiling Type), Zeche Minister Stein, Dortmund, Germany,* 1987

constitutes only one aspect of his artistic practice, since he also paints and sculpts. In his multimedia work Förg presents his photographs both as parts of an ensemble, in site-specific installations, and as autonomous entities. Förg's images dealing with death are highly original, especially when he focuses on his own death—for example, in a photograph of himself lying shattered at the foot of a stairway. His window pictures, which he makes in buildings that are famous examples of Modernist architecture, treat not only the interior design but also the external surroundings. Here, the clarity, sternness, and precision with which Förg depicts these buildings reflects the harmony and proportion of the structures themselves. Blown up to the size of windows, these photographs, with their enlarged grain, develop their own coloristic lives, reflecting Förg's painterly side.

The fact that optical precision can be used to serve a variety of goals is further underscored by Bernhard Prinz's photographic oeuvre. Starting with architecture, Prinz initially exhibited furniturelike objects into which he integrated his photographs. Next came still lifes set up specifically for the camera, pieced together out of the most diverse domestic items—silverware, vases, knickknacks—which he garnished with luxurious textiles, creating lush images recalling the rich attention to objects found in advertising product shots.

In his latest works, Prinz has turned to the portrait, and especially the allegorical portrait, arranging his sitters in simple yet dramatic poses of a sort found in photo-studio shots from an earlier era. Only the oversized prints and the elaborate wooden frames—which Prinz constructs himself—make the resulting works different from their thematic counterparts in studio photography. Portrait photography as a craft is thereby raised to the level of art. As in advertising, the objects and the portraits offer a seductive image, but here the photographs are meant only to refer to advertising, to suggest through this irritation new dimensions of interpretation.

Prinz's work quotes former photographic styles only ironically. In this his photographs are comparable with those of Ruff and, to a lesser extent, Gursky and Struth. If Prinz's portraits look like pictorial studio portraits from the beginning of the twentieth century, or his staged photographs like advertising pictures from the 1920s and '30s, they do so allegorically. Prinz—like many other artists today—uses historical images in a process of art recycling.

Cinema and especially TV have taken over the task of recording reality from photography. In the coldly calculated pictures of Struth, Gursky, and Ruff, as well as in the staged pictures of Förg and Prinz, reality appears again, in an elevated, aesthetic form. The balanced and contemplative images of these artists display an Apollonian spirit. Behind their mask of opticality we find competing impulses toward tradition, modernism, and timelessness. In these works photography regains what it has lost through overuse: its aura. □

Translated from German by Joachim Neugroschel.

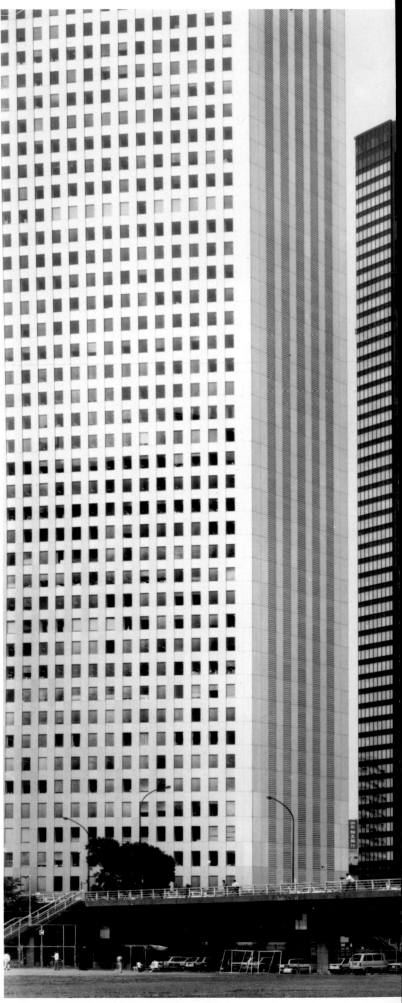

Thomas Struth, *Shinju-ku, Tokyo,* 1986

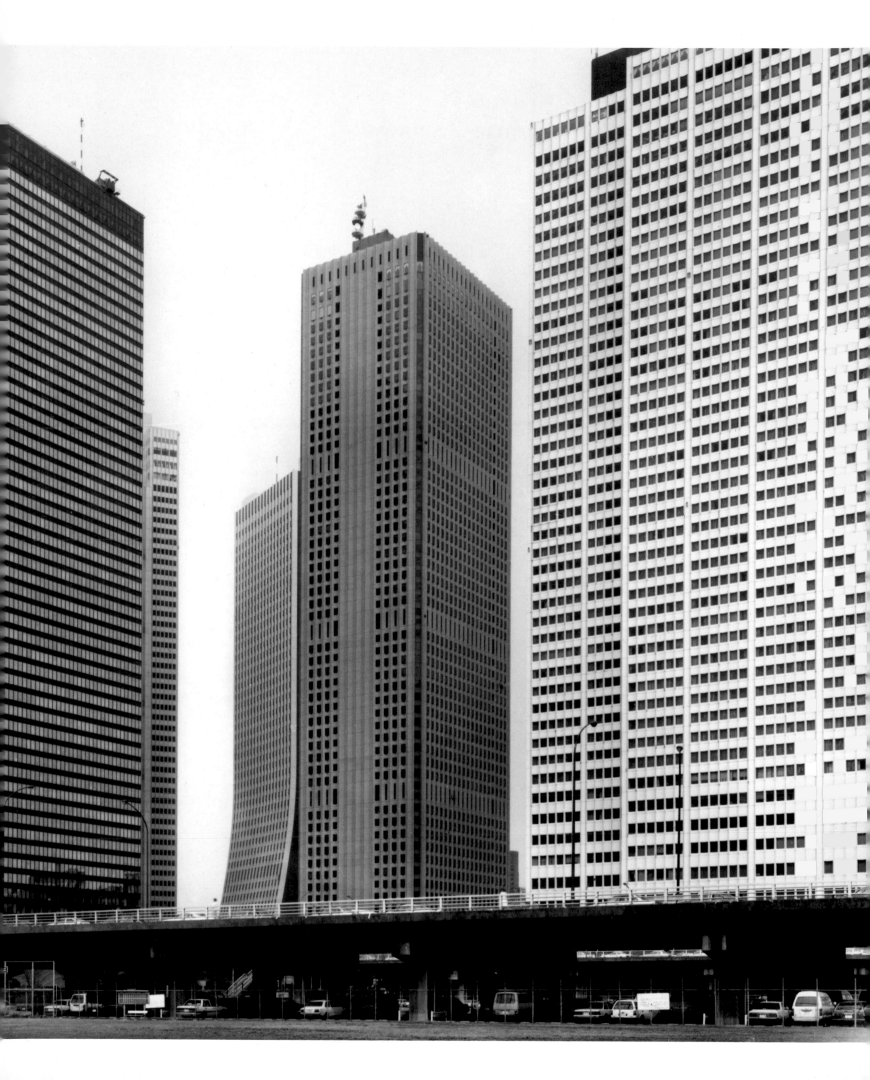

The Metaphysicians of Dionysus: Comments on the New German Photoworks

By Wilfried Wiegand

Influenced by painting, performance art, and other media, many German artists are pushing photography in a new direction marked by formal innovation and psychological drama.

The history of German photography after 1945 can be divided into three major chapters, each of which has been the labor of a different generation. The first era was shaped by people whose cardinal experience had been Germany's total collapse in 1945; a second chapter began with the "generation of 1968"; and the third chapter, which has been evolving for several years now, is that of a postmodern "post-1968 generation."

The first generation was marked by the fateful legacy that National Socialism bequeathed to German art: a general distrust of beauty. Since beauty could be so thoroughly misused for lies as it was under the National Socialists, then wouldn't it be better to create an art that was not beautiful? Joseph Beuys, the greatest German postwar artist, produced just such an art. This art is no longer beautiful; it is only true. And it is true precisely *because* it is not beautiful, because it intentionally destroys beauty. Beuys established a new German tradition, which can still be seen today in the work of, say, the painters A.R. Penck and Georg Baselitz. Releasing truth from beauty has turned the latter into a kind of waste product, which emerges from artistic works peripherally—a leftover.

Photography since 1945 has likewise adhered to an aesthetics of destruction—although it didn't have to make any special efforts along these lines during the early postwar years. The basic motif of destroyed beauty was supplied by the pictorial theme that dominated everything: a Germany lying in ruins. Photography in Germany was almost involuntarily an art without glamour, an art of meagerness—an Arte Povera. Even the Subjective Photography group, which tried to reconquer beauty for German photography, failed to present beauty in all its aspects. What this trend essentially accomplished was to rehabilitate photographic abstraction. Artistic freedom seemed to clap itself into chains with its understandable urge for aesthetic "reparations." Subjective Photography showed beauty—as staged by a bad conscience.

The birth of a radically new German photography did not occur until many years later. This new German photography was produced by the generation of 1968. The cultural revolution that occurred in that period was based upon a far-reaching critique of the mass media. Television, cinema, photography, journalism, and advertising were suddenly viewed as the instruments of a global brainwashing aimed at spreading propaganda for the capitalist way of life. In no Western country was this criticism voiced more shrilly than in the Federal Republic of Germany. For here it evoked painful memories of the totalitarian propaganda inflicted upon the German people under Hitler. The media theories expounded by Theodor Adorno, Walter Benjamin, Bertolt Brecht, Max Horkheimer, and Herbert Marcuse were treated as classics. From that moment on, we in Germany knew how to categorize photography: it was neither art nor documentation, but simply a *medium*. Photography had finally come under ideological suspicion.

Since that period, even documentary photojournalism in Germany has included a streak of distrust toward the medium of photography and toward beauty and art. The new German reportage photography is wary of both anecdote and composition. Its truth emerges only incidentally and has to be deciphered like certain literary texts, which make their most important statements between the lines. Reality in these photos appears to be living under a gag order. At first glance, the photographers seem to be cleaving to that silence—until one discovers that their pictures are secret messages, encoded utterances, subtexts. The photos shot by the young German reporters differ from classical reportage photography in the same way that the New German Cinema differs from Hollywood and the commercial German movie tradition. In those films and those photographs, the medium's claim to truth never coincides with reality. Truth and reality seem to reject one another.

But if photography is a medium that can be endlessly manipulated, why not advance one more step and drive the aesthetics of rejection to the point of its becoming an aesthetics of intentional destruction? The new German "photoworks" have chosen this route. They take photography as a medium at its word by manipulating it quite openly. Photography is destroyed, often quite literally, but also more subtly in that its specific qualities are demolished or intensified *ad absurdum*, in almost caricatural exaggeration. Photos can now be so fuzzy, so shaky, so devoid of any composition as to look downright amateurish. Yet on the other hand, they can be so precise, so accurate, so large that we are dealing not with a layman's subrealism, but with an almost scientific hyperrealism.

In any case, the aesthetics of photography is thereby nulli-

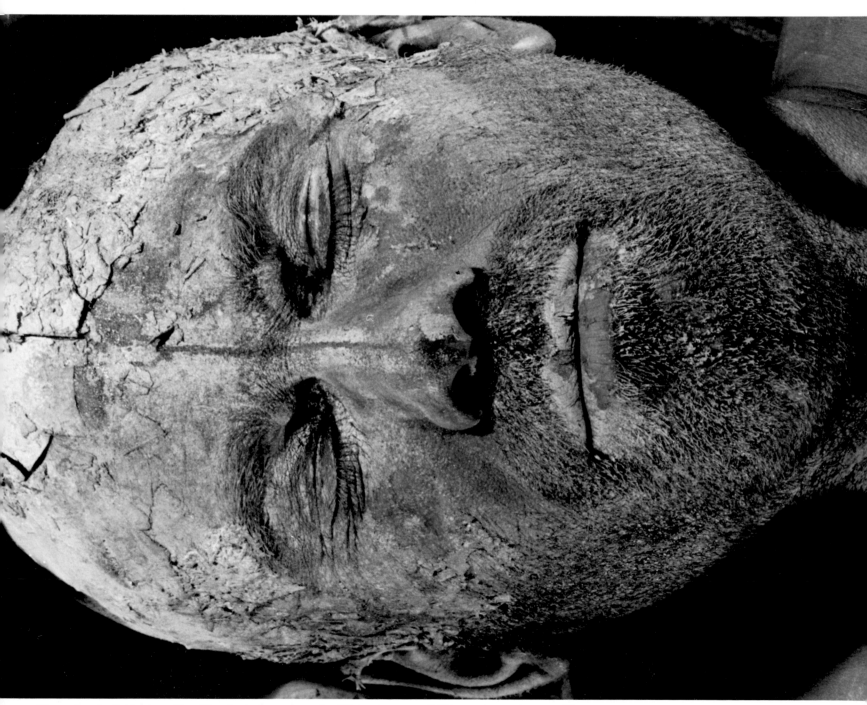

Dieter Appelt, *Schichtung* (Stratification), from the series *"Erinnerungsspur"* (Memory traces), 1977–88

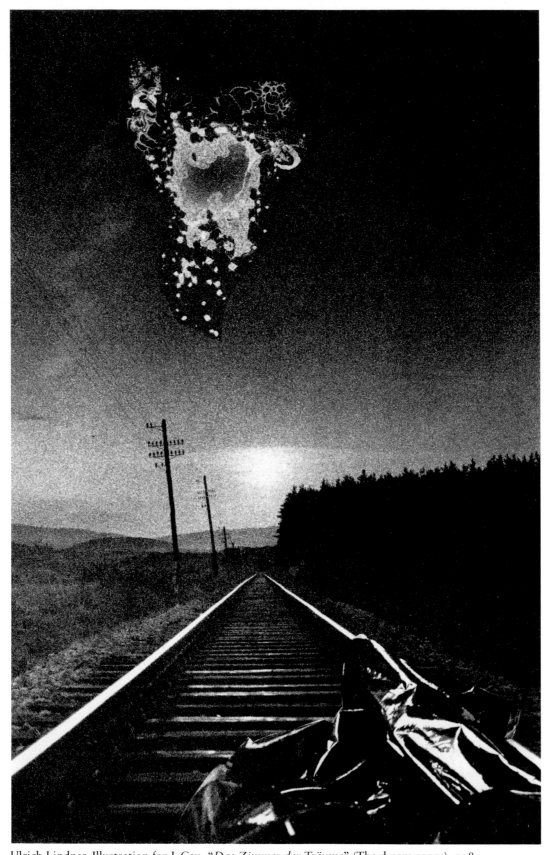

Ulrich Lindner, Illustration for J. Cau, *"Das Zimmer der Träume"* (The dream room), 1984

Right: Gerd Bonfert,
Augenlicht Bild B 69-5
(Eyesight picture B 69-5), 1984

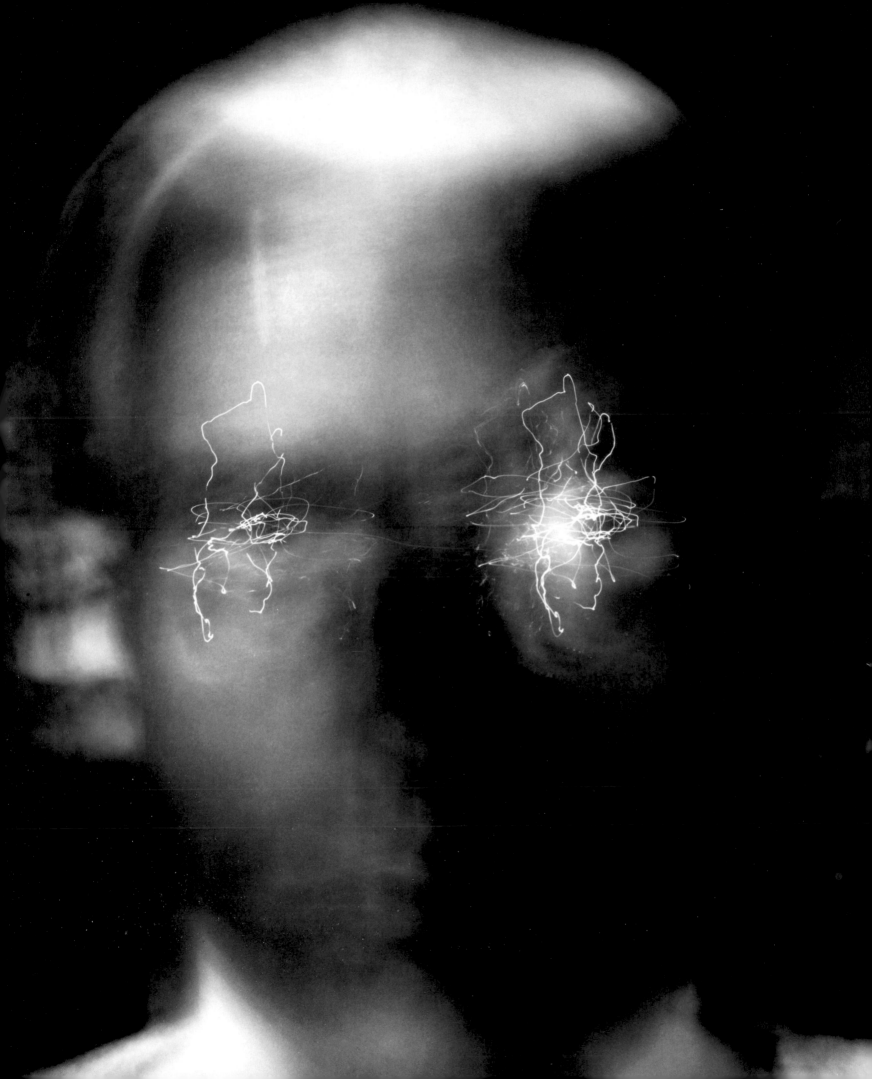

Floris M. Neusüss, *Japanese Garden*, 1988

Right: Ulrich Tillmann, *Brühlsche Terrasse, Dresden*, 1990

Silke Grossmann, *Untitled*, 1985

Silke Grossmann, *Untitled*, 1982

76

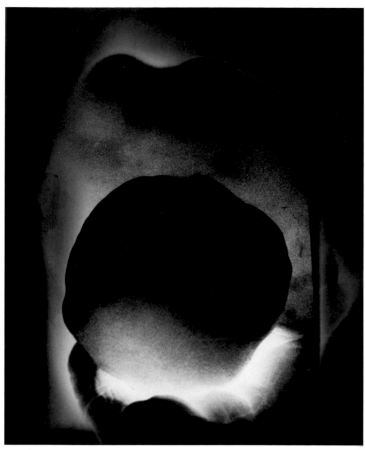

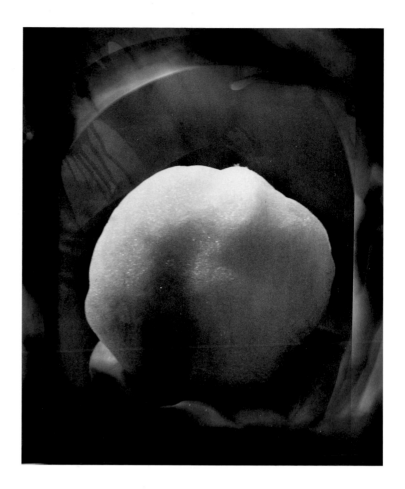

Dörte Eissfeldt, from *Schneeball* (Snowball), 1988
left: #11; right: #6

fied. For if the beauty of an artwork is *artificial* while the beauty of a photograph, in contrast, is *found*, then don't these photoworks belong to an aesthetic no-man's-land? That is the true provocation of new German photo art: it accepts no aesthetic pinpointing, it resists traditional methods of art consumption. It practices an art that rejects artistic aesthetics but flirts with photographic aesthetics, yet it refuses to be photographic, and it seems pretentiously to pass itself off as art. The compromise formula, labeling this an art that simply employs photochemical aids, is off target. For in some cases, it takes the form of what would be considered—from this technical viewpoint—pure photography, but it is obviously not interested in the qualities that photographers normally try to achieve. Whatever the artistic effect of all these works, they generally employ photography as a kind of commentary: each of these photoworks also tells us something *about* photography. Independent of what we see, photography thereby becomes visible as a medium. This means more than its being used as simply material in the creative process. What we see is not just art with photography; rather, we see something new: art as photography.

Thus, these innovative German photoworks contain many of the factors that helped to advance postwar German photogra-

phy: a bad conscience about art, distrust of beauty, a critique of the medium. These elements of a negative aesthetics—which admits beauty only as the result of destruction, criticism, rejection, a calling into question—make these photoworks very German. Comparable works in America or France seem more naive, more accepting of beauty—and of the medium that makes beauty visible in the first place. And if any kind of distancing is still undertaken, then it is used to testify to a Cartesian intellectuality good and proper. Unlike German art, the art of those countries turns even brokenness into something beautiful.

German photoworks are, in a highly complex way, mnemonic instruments—even for remembering all the directions, right or wrong, in which German photography has headed during our century. This universal willingness to quote makes the new German photoworks typical of our postmodern present. Often, German photoworks treat the avant-garde aesthetics of the 1920s the way today's "wild" painters treat the legacy of Expressionism: they not only resort to the same motifs and materials, they frequently also quote an artist's stance. What we then see is not a copy of Expressionism, but an Expressionist gesture. There is something playful in this joy of quoting, something theatrical. A choreographic mise-en-scène has vir-

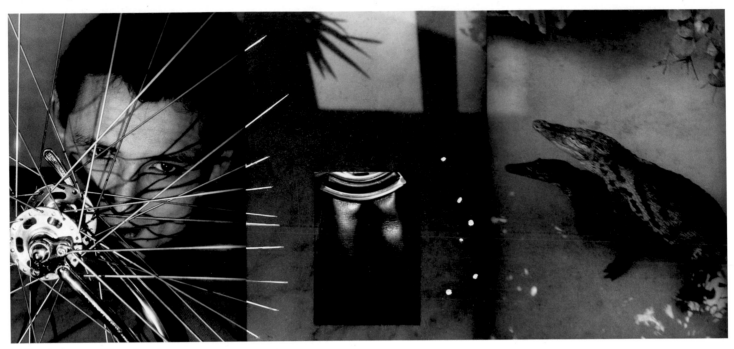

Pidder Auberger, *Zigurd*, 1983

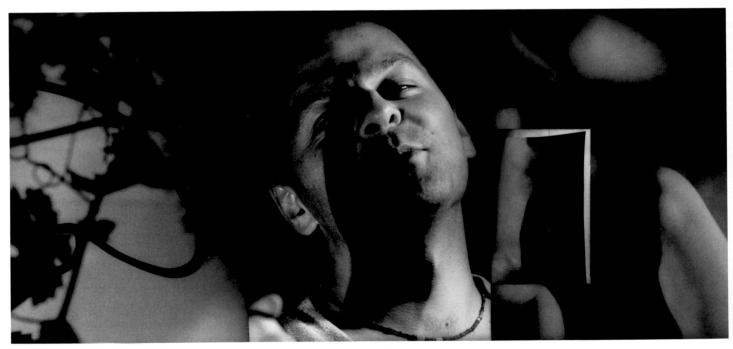

Pidder Auberger, *Bogo*, 1983

Astrid Klein,
Verführung-Sklaverei III
(Seduction-Slavery III), 1988

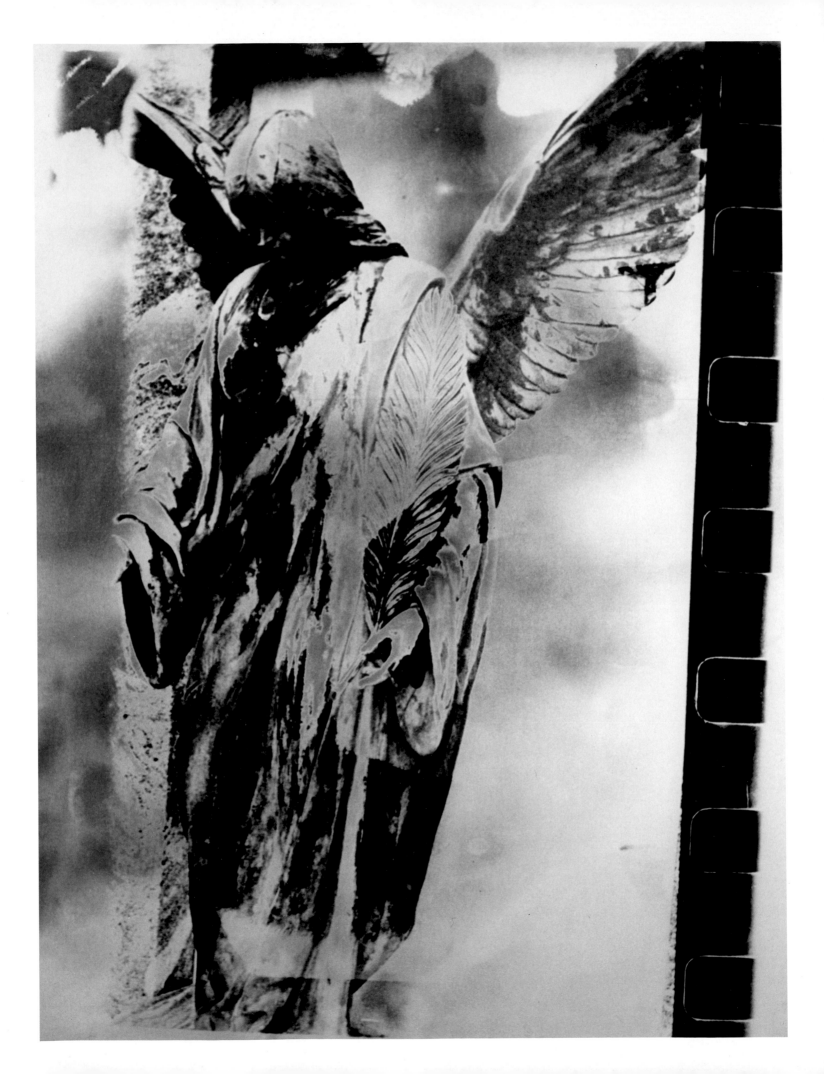

Johannes Brus, *Während einer Expedition in mein Unterbewusstes zeigt F. Marc S. Freud den Berg "Wildes Denken", worauf dieser rot wird* (During an expedition in my subconscious F. Marc shows S. Freud the mountain "Wild Thought," which makes him blush), 1979

tually appropriated diverse stylistic elements and arranged them into a dance.

In Bernhard and Anna Blume's work, this dance element is obvious. The props of petty bourgeois triteness perform an absurd ballet, a kind of German slapstick. Other photographers, such as Dieter Appelt, Dörte Eissfeldt, Astrid Klein, and Thomas Florschuetz, favor a still-life presentation. However, their objects similarly come from everyday life, often from their own immediate surroundings. All the motifs seem very near and palpable, like props, available like one's own body, which for some photographers—most obviously Floris M. Neusüss—can become a favorite model. Nowhere do we feel a yearning for faraway places; the world seems to have become very tiny, like a prison cell, whose browbeaten inmates feel menaced by a ubiquitous banality. Or else they make absurd efforts to communicate, thereby getting bogged down in senseless rituals, as if they had nobody to link up with: examples can be found in Jaschi Klein's anti-fashion photography or Dieter

Appelt's and Jürgen Klauke's body mise-en-scènes. The link among all these works is the aesthetics of grotesqueness. These pictures, filled with ambiguity, are both shocking and comical at once; they are documents of a black humor that is exceedingly rare in German art.

But why bother? What is the ultimate goal? Do these photoworks attain something that paintings, works on paper, and traditional photographs are unable to bring about? There is indeed something that a comparable purity and radicality seldom produce in the current art scene. It may very well be the most precious thing that present-day art can make visible: freedom. A photowork is the artistic medium of total freedom. The resulting creative gain can be likened to the aesthetic combinatorics, the acceptance of all possible arrangements of motifs and materials, that Robert Rauschenberg once conquered for graphic techniques. In regard to German photoworks, freedom means being as free as possible from the rules governing rhetoric in the visual arts. Neither the young Ger-

Bernhard and Anna Blume, from "*gegenseitig*" (mutual), 1987–88

Right: Sigmar Polke, *Paris*, 1971

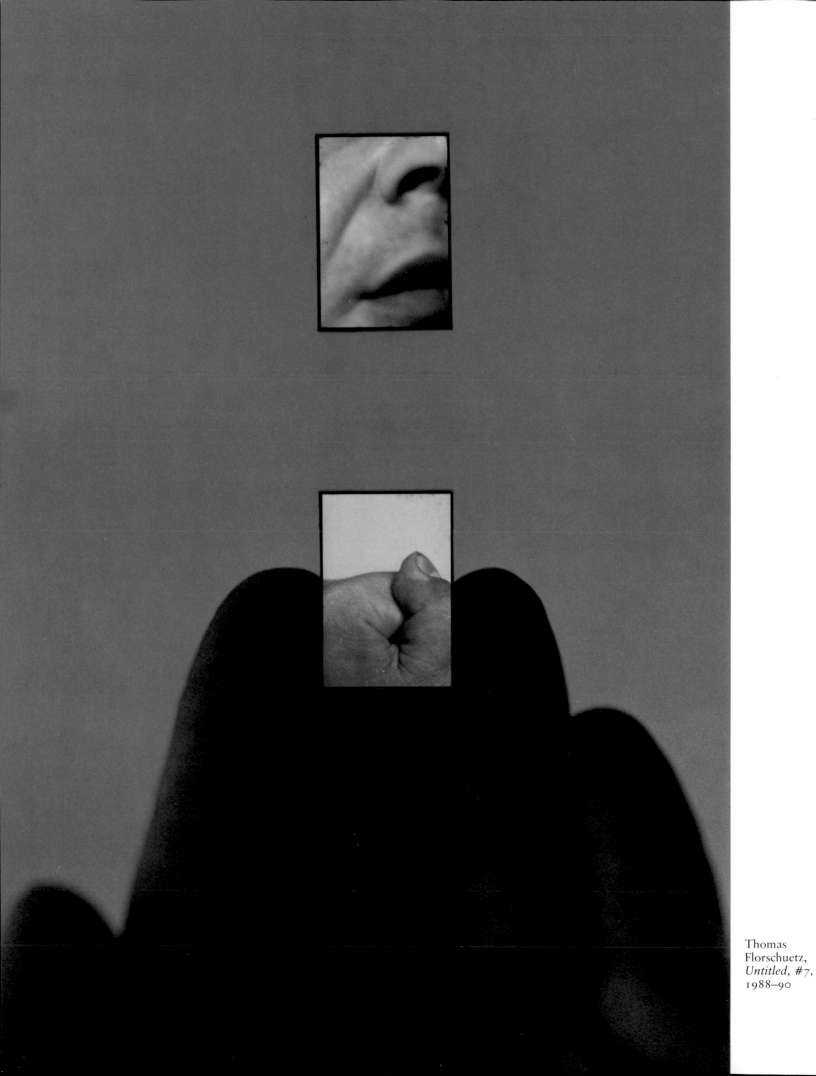

Thomas
Florschuetz,
Untitled, #7,
1988–90

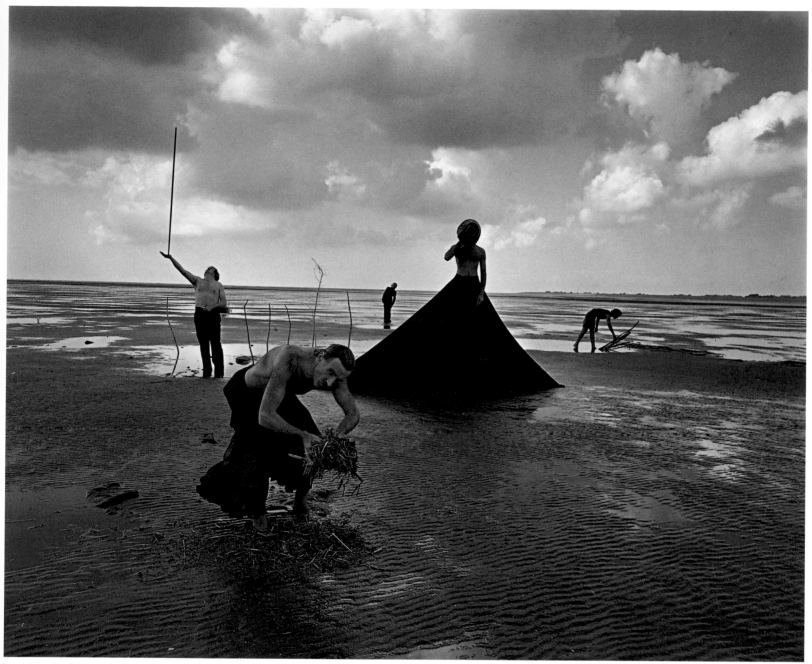

Jaschi Klein, *Untitled*, 1987

man painters who now begin working on their blank canvases nor the young German photographers who make snapshots typical of the times are even remotely as free in their artistic decisions as the artist who produces a photowork. For the modern photo artist, that burden of the various kinds of artistic rhetoric has developed into something that weighs very little in the overall aesthetic game: a randomly employable piece of a metaphysical puzzle.

And what has become of all those strictures of postwar German art and photography: "Thou shalt distrust art!", "Thou shalt destroy beauty!", "Thou shalt criticize the media!"? Are these commandments no longer valid? Or have they actually faded into oblivion? As rules, they have lost their moral impetus, which can now be obeyed only formally. In the new German photoworks, photography has once again become an art that is only just starting out—free of fetters, but not free of memories. A photowork is an aesthetic adventure, an artistic quest. The ineradicable question asked about a photowork, "Is it art or is it photography?", could be provocatively answered as follows: "It is neither art nor photography." It is something new, for which we still have to find a conceptual formula. It is quite normal to be groping for words when you enter the space of freedom. □

Translated from German by Joachim Neugroschel.

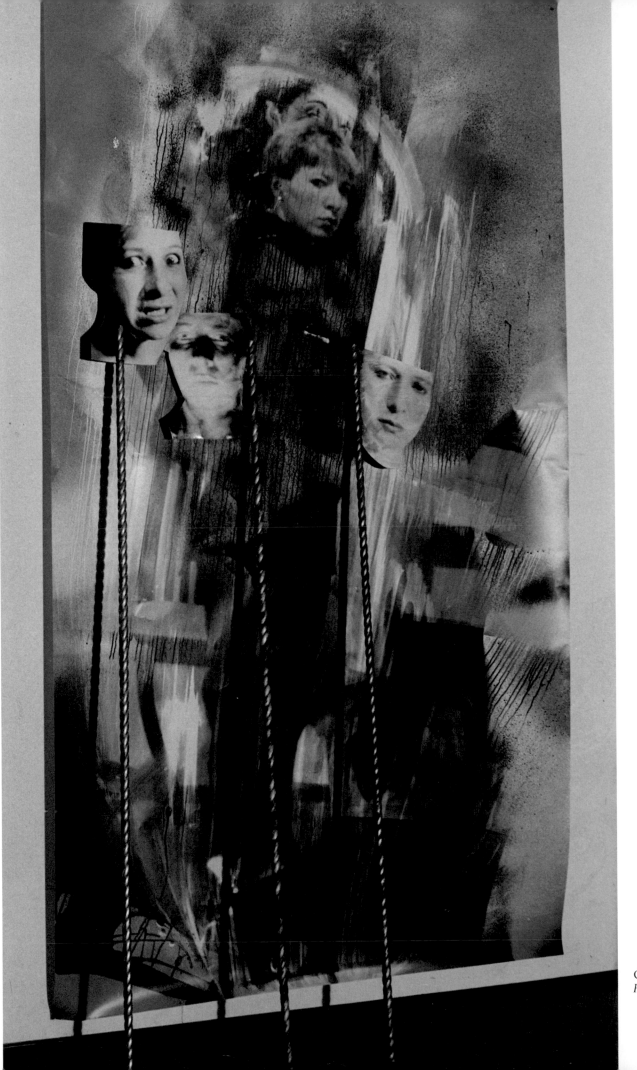

Carmen Oberst,
Fahnende Gesichter, 1987

Anselm Kiefer, *Das Schlangenwunder* (The miracle of the serpents), 1984–85

People and Ideas

When the Nazis came to power in Germany in 1933, the loss for photography and culture in general was vast. In the liberal climate of the Weimar Republic, German photography had been astonishingly innovative. But with the rise of the Nazis all that changed. Many artists fled the country, while others were forced into concentration camps and often killed. Those who were deemed by the Nazis to be "clean" were allowed to stay, but suffered under severe restrictions; schools, universities, and magazines were shut down by the new regime. For many, a kind of "inner emigration" became the only way to survive. Hans Bellmer, who refused to work commercially in protest against the Hitler regime and then left the country and even gave up his citizenship in 1941, exemplifies the sacrifices many artists made.

After the war some of the artists who had been forced into exile came back, but most stayed where they had found new lives for themselves. Like the rest of postwar German society, artistic culture had to be rebuilt from the ground up.

After Germany was split into two separate states in 1948, the Western part was deeply influenced by American culture. One of the most widely respected German photographers in this period was Otto Steinert, a medical doctor who turned to photography. Steinert championed a personal yet abstract style of photography, and together with Peter Keetman, Toni Schneiders, Ludwig Windstosser, and others he formed the group "Fotoform." The work of these photographers, who used both straight photography and various darkroom techniques, included portraits, landscapes, and still lifes, and was labelled "Subjektive Photographie."

During the late 1950s and '60s Steinert was by far the most influential teacher of photography in Germany, first in Saarbrücken and later at the Folkwang Schule in Essen. At the time there was no market for art

photography—the first gallery for the medium in Germany was noncommercial, opened in 1952 in Hamburg by the city-state; no museum regularly showed photography, either. For this reason Steinert was keen to train his students in practical skills. Many of his students—among them Heinrich Riebesehl, Detlef Orlopp, André Gelpke, Timm Rautert, and Arno Jansen—have worked as photojournalists, advertising photographers, and teachers while continuing to produce their personal photography.

Since there was no public photographic collection in Germany at that time, Steinert started his own study collection. Later it became the basis of the Fotografische Sammlung of the Museum Folkwang in Essen, where Ute Eskildsen, a former student of Steinert's, has been curator of photography since 1978.

In that same period a valuable showcase for contemporary work was provided by the *Bilderschau* exhibitions, organized by Fritz L. Gruber for the biennial Photokina in Cologne. Two important professional societies also helped to foster a dialogue among photographers: the *Deutsche Gesellschaft für Photographie* ("DGPh", German society of photography), founded in Cologne in 1951, and the *Fotografische Akademie GDL*, successor to the *Gesellschaft Deutscher Lichtbildner* (Society of German photographers), founded in 1919.

The student revolution of 1968 brought about a major change in the German university system. Former art schools such as the Folkwang Schule were transformed into secondary art academies, existing alongside the established art academies in Düsseldorf, Hamburg, Munich, and Berlin. This shift opened up teaching jobs for many photographers. These people are part of the uniquely German system of *Beamte*, or minor officials. A "Beamter" enjoys special privileges, including appointment for life and a civil service pension. In education, an unfortunate side effect of this system—at least in my experience—is that often the creative work of the teacher suffers.

Generally speaking, the German photo scene today lacks strong individuals who are fighting with their whole beings for their artistic aims. Thus there is no one in Germany like Robert Adams, working as both a photographer and a writer; there is no Lee Friedlander, a person who can look back over a career of thirty years of innovative work; there is no Minor White, who was both a passionate teacher and photographer; there is no imagemaker of the stature of the color photographer William Eggleston. In fact, there are few dedicated people teaching photography in the universities now, and many of those waste their energy in photo-politics and infighting rather than attending to serious photography.

In 1972 photography was shown for the first time at "documenta," the international art show held every four years in Kassel. Because various other art forms relied on photography as a means of documentation, the inclusion of photography was not a sign that the medium was being recognized as an art form in its own right. But the acceptance of photography used to document artworks opened the way for other kinds of photography to be accepted into museums and private art collections. Soon commercial galleries began to show work of serious photographers.

In the early 1970s, for example, the Galerie Wilde in Cologne showed such American photographers as Lee Friedlander, Duane Michals, and Les Krims, as well as Albert Renger-Patzsch, Florence Henri, and August Sander. The Photogalerie Spectrum, founded by photographers in Hannover, exhibited UMBO and contemporary American color photographers as well as Robert Häusser and such young talents as Rautert. Other galleries opened up, publications were started, and photographers such as Riebesehl, Gelpke, Bernd and Hilla Becher, Michael Schmidt, Wilhelm Schürmann, and Verena von Gagern were increasingly able to sell their work, although few were able to live off these sales.

By the end of the '70s the photo-

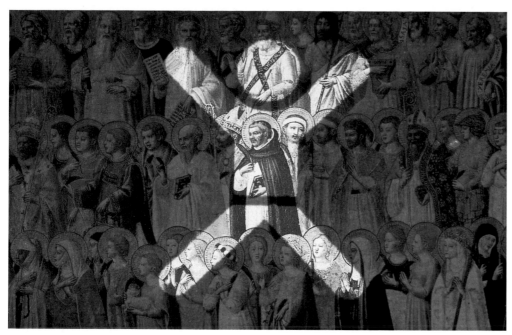

Andreas Horlitz, *Untitled*, 1987

graphic scene in Germany had become very active, although it remained separate from the art world. But by that time museums and *Kunstvereine* (art societies) had begun to show not only photographs by such recognized artists as Wols, Raoul Hausmann, and Moholy-Nagy, but also work by Renger-Patzsch, Sander, and other photographers. Gradually, support for independent photography grew. In 1979, curator Klaus Honnef of the Rheinisches Landesmuseum, Bonn, presented "In Deutschland," an exhibition of documentary German photography. Honnef invented the term "*Autoren fotografie*" (Auteurs' photography) to describe the personal documentary style pursued by the photographers in the show, who included the Bechers, Riebesehl, Thomas Struth, Wilmar Koenig, and others. In Berlin, Michael Schmidt founded the *Werkstatt für Photographie* (Workshop for photography) in an adult evening school; here photography was taught as both an expressive and documentary form. Exhibitions and workshops with Eggleston, John Gossage, Lewis Baltz, and various German photographers exposed the students to contemporary work in both America and Germany.

Germany is divided into small states, which together form the Federal Republic of Germany; as a result no one city is the cultural capital, and there is no National Museum of Photography. Some states support the arts more than others, but even today only three institutions regularly collect contemporary photography: Museum Folkwang in Essen; Berlinische Galerie, where curator Janos Frecot collects photography with an emphasis on work done in Berlin; and, very recently, the Staatsgalerie in Stuttgart. Institutions with major collections of historical photographs include the Agfa Historama, which is integrated into the Museum Ludwig in Cologne, and the Museum für Kunst und Gewerbe in Hamburg.

By the beginning of the 1980s the new market for photography collapsed. Only historical works or images by photographers who had already been accepted into the art world—for example, the Bechers—continued to sell. The reason for this shift was the appearance of neo-Expressionist painting, which achieved great success in the art market. After a while, though, young artists including Walter Dahn, Milan Kunc, and Martin Kippenberger began to work with photography, while older colleagues such as Gerhard Richter, Sigmar Polke, and Anselm Kiefer began to exhibit their own photographic work. Photography was again accepted in the art world—perhaps more fully than at any time since the Second World War.

In the 1980s, with the German economy booming again, a number of younger photographers achieved prominence.

Bernd Becher, at the art academy in Düsseldorf, has brought forth a whole generation of students, among them Thomas Struth, Thomas Ruff, Andreas Gursky, Axel Hütte, and Candida Höfer, trained in the strategies of survival as an artist. In Essen the Folkwang Schule, now integrated into the local university, has produced such photographers as Joachim Bröhm, Andreas Horlitz, Gosbert Adler, and Volker Heinze. A number of former students of Michael Schmidt, including Wilmar Koenig and Ulrich Görlich, who was included in the last "documenta," have achieved acceptance in the galleries, as have such other artists as Dieter Appelt, Heiner Blum, Thomas Florschuetz, Astrid Klein, and Rudolf Bonvie.

An effective net of financial support in the form of grants and prizes ensures the continued growth of artistic photography. In Essen, Ute Eskildsen has helped organize various grants and commissions; it is due to her efforts that the Krupp AG and the Alfried Krupp von Bohlen und Halbach Foundation have supported independent photography in various ways for the past decade. Besides the *Kunstfonds*, or grants underwritten by the government, three competitions are sponsored by banks or insurance companies. Another form of support for contemporary photography is provided by the Siemens AG, one of Europe's biggest communications-technology companies, which sponsored a project in which twenty participants were invited to photograph in Siemens factories.

Today German photography has reached a new point of independence. With the reunification of the country, photography—along with much else—will undoubtedly change. East German photographers, whose work has been oriented mainly toward a humanistic, journalistic aesthetic, will likely respond to their changed situation by moving in a variety of new directions. By the same token, their influence—and the changed circumstances of the country—may bring a renewed interest in documentary investigations. As a result of all of this activity, a truly authentic German photography may arise once again. And in time, it may even reach the tremendously high standards set by photographers and artists before the war.

FROM THE END OF THE WORLD TO SMACK DAB IN THE MIDDLE:
An Interview with Wim Wenders
By Charles Hagen

Wim Wenders had just returned to Berlin from shooting his next film, *Until the End of the World*, when we spoke with him recently. "It's fantastic," Wenders, one of the leading filmmakers of the postwar generation, said of the changes that have overtaken the city in the past year. "I've been walking all over, last night and the night before. The place I live is right at the Wall—or at least it used to be right at the Wall. People used to ask me why I moved here, because it was the end of the world. And now I'm in the middle of the city. I'm really smack dab in the middle. I jog every day," Wenders continued, "and before, my path led me along the Wall; now I just go straight through. There's nothing left—it's just one gigantic no-man's-land, which is ideal for running."

Shooting *Until the End of the World* was a grueling experience. The film, due to be released in summer 1991, stars William Hurt as a man who roams the world gathering information for his father, a scientist searching for a way to bring sight to his blind wife. (The film also features Solveig Dommartin, Max von Sydow, Jeanne Moreau, Sam Neill, and Rüdiger Vogler, as well as music by David Byrne, Peter Gabriel, Lou Reed, and Ry Cooder, among others.) To film the story, Wenders and a small crew shot for twenty weeks in eleven countries. The completion of filming marks the next step in a project Wenders began in 1977. "It was only after the relative success of *Paris, Texas* and *Wings of Desire* that a budget like this film needed—which was finally $22 million—was available to me," Wenders says. "Apart from that it was always a logistic nightmare. I finally just had to tackle it, because it was overdue."

"I think one trait you have to have as a director is to be stubborn," Wenders continues. "On a day-to-day basis, and also on a year-to-year basis. You have to keep pushing what you want to do. You have to be stubborn not just about your projects, but also about your vision, down to the framing of each shot. I'm a formalist. I very much believe in form, in a visual grammar, in the frame—both in movies and in still photography. As a director I think one has to have a strong belief in form. And somehow that goes well with stubbornness."

Along with his filmmaking Wenders is an avid and accomplished photographer. *Written in the West*, a book of color photographs Wenders made in the American West just before shooting his film *Paris, Texas*, was published in 1989 by Schirmer/Mosel Verlag. "As a filmmaker, a big part of taking pictures is strictly in preparation for the movie," Wenders reports. "If you go on location scouts you take pictures like crazy. I took hundreds, thousands of pictures in the course of preparation for *Until the End of the World*. But because I have to take so many pictures that for me don't count as photography, every now and then I'm happy just to photograph without any particular purpose. Most of the pictures in *Written in the West* were of this sort. They were made with a 6×7 cm. camera, of places that were not going to be in the film. I'm actually quite proud of these photographs, because I made them without any purpose except to understand the light of the West, and the landscapes I would photograph in the film.

"I did much less photography during *Until the End of the World*," Wenders continues. "There was just no time. I had all my cameras with me, but it got to the point where I just had no energy left to do anything but the movie."

Wenders rarely makes photographs that are not related to a film he's working on. "As soon as you have a film in mind, even if you're a long way from shooting it," he says, "then whatever you do, physically or mentally, becomes part of your preparation. If you know that in six months you'll shoot a film in black and white, it's very difficult to take a color photograph. You have to prepare to see the world in a certain way, and you have to prepare to have an attitude toward the world and toward a certain story and a certain form that you want to use. It's almost a physical thing, to be in preparation for a film. And if you take a photograph, you have to obey whatever mode you're preparing for.

Wim Wenders, *Near Coober Pedy, South Australia*, 1988

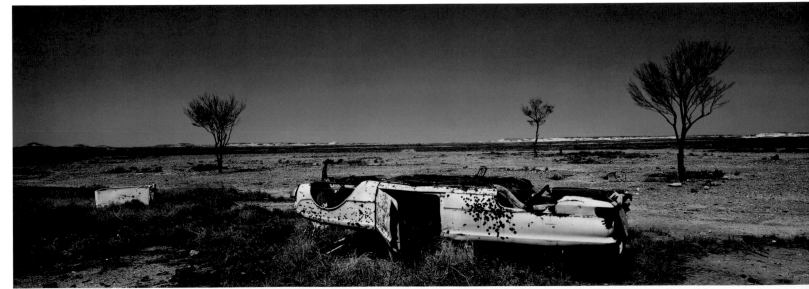

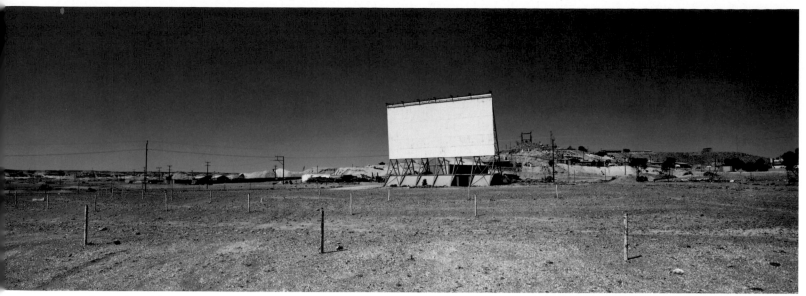

Wim Wenders, *The Old Drive-In Theater, Coober Pedy, South Australia*, 1988

"I did panoramic photographs in Australia," Wenders notes, "because for a long time I thought we might shoot *Until the End of the World* in a panoramic, scope format. Finally—and in part because of the panoramic photographs—I realized that applying this wide frame to the movie was going to make me give up too many things that were dear to me. So we went back to the regular 1:1.66 frame. And as soon as we started shooting I was very happy I had made that decision."

Amidst his film work Wenders tries to keep up with the current photo scene. "I go to lots of galleries," he says. "I like seeing photographs; I have hundreds of books of contemporary photographers. For me, looking at other people's photographs is one of the biggest pleasures, or leisures. It's one of the nicest things, next to listening to music or reading a book."

In films such as *Kings of the Road* and *The American Friend*, Wenders has made the mechanics of moviemaking an integral part of his stories. He's well aware of the connection between photography and the optical toys that were forerunners of motion pictures. "I think the most fascinating time in photography was the beginning," he notes. "I've always had a project to make a film about the invention of photography. I've done research on all these lesser-known inventors who were trying to do the same thing at the same time. If I make the film, though, I'll probably use a fictional character—someone who can't do it, can't get the image to stay."

Another film Wenders has long thought about making deals with the question of fascism. "Every now and then I'll cut out an article or put a book on the shelf for this project," he says. "It's now a very heavy shelf, so I think I'll get to it after finishing *Until the End of the World*. It will be a contemporary film, not a historical film, about the latent presence of fascism. I think it's more interesting to do it now, with reunification, then it would have been a couple of years ago."

A central theme in many of Wenders's films has been Germany after the war. With all the recent political changes in the country, he sees a reassessment of Germany's sense of itself to be inevitable. "On one hand," he argues, "a certain reassessment is going to have to take place, for the simple reason that the seventeen or eighteen million people from the East have a different notion of being German. They've had a different way of thinking, and a different social structure—it was almost as if they've been living on a different planet. And now it's one planet again.

"The notion of being German has to be redefined," Wenders continues. "But the interesting thing is that it will have to be redefined in two ways—in regards to Western Europe, on one hand; 1992 is only one year away, and Europe will be a continent without frontiers. On the other hand, all the Eastern countries are now opening up, Poland and Czechoslovakia and so on. So Germany will have to define itself to both the West and the East. It'll be extremely interesting to see what comes out."

AARON SISKIND, 1903–1991

Aaron Siskind, renowned photographer and teacher, died on February 8, 1991, at his home in Pawtucket, Rhode Island.

Born in New York in 1903, Siskind taught English in the New York public schools before turning to photography in the 1930s. With other members of the Photo League Siskind produced a series of documentary studies, among them "Most Crowded Block" and "Harlem Document." In the early 1940s Siskind discovered the radical transformation of space and meaning that could be achieved by depicting such subjects as seaweed, a fisherman's glove, or stone walls in extreme close-up. In later years Siskind continued to explore the emotional and formal suggestions to be found in almost abstract close-ups of patterns of paint on walls, peeling posters, and strips of tar on roads.

For many years Siskind was an influential teacher as well, joining Harry Callahan first at the Institute of Design, Chicago, and later at the Rhode Island School of Design.

Siskind continued to photograph actively until the last year of his life. "I don't give a damn much for fame," Siskind said a few days before his death. "I like the idea that I have enough money to live well, to take care of myself and my friends. But the only fame I care about is the fame of intelligent people."

CONTRIBUTORS

GOSBERT ADLER, born in 1956, studied photography at the University of Essen. He lives in Berlin.

DIETER APPELT, born in Niemegk in 1935, studied experimental photography with Heinz Hajek-Halke in Berlin, where he now teaches at the Academy of Art.

URSULA ARNOLD, born in 1929 in Thuringia, studied photography at the Hochschule für Grafik und Buchkunst in Leipzig. She lives in Berlin.

PIDDER AUBERGER, born in 1946 in Lohberg, studied at the Staatliche Kunstakademie in Düsseldorf, where he now lives.

BERND AND HILLA BECHER have photographed industrial regions in Germany and abroad since the 1960s. Since 1976 Bernd Becher has been professor of photography at the Staatliche Kunstakademie Düsseldorf.

Born in Berlin in 1941, SYBILLE BERGEMANN studied photography under Arno Fischer.

BERNHARD AND ANNA BLUME have collaborated on photographic projects since 1980. They live in Cologne.

GERD BONFERT, born in Romania in 1953, has lived in Germany since 1973.

JOHANNES BRUS studied at the Staatlichen Kunstakademie Düsseldorf from 1964 to 1971; he lives and works in Essen-Kettwig.

Born in St.-Tönis-Krefeld in 1954, WALTER DAHN studied painting at the School of Fine Arts in Düsseldorf under Joseph Beuys.

CAROLINE DLUGOS studied sculpture and photography under Harry Kramer and Floris Neusüss. She lives in Berlin.

DÖRTE EISSFELDT, born in 1950, studied at the Hochschule für bildende Künste in Hamburg in the 1970s. She lives in Hamburg.

JOACHIM ELLERBROCK AND GERHARD SCHAFFT, born in 1950 and 1942 respectively, met at the Hochschule für bildende Künste in Hamburg in the mid 1970s. Members of the Bilderberg agency, their work has been widely published.

MICHAEL ENGLER, born in 1942, has been a freelance photographer in Hamburg since 1976. He is a member of the Bilderberg agency.

Born in 1957, THOMAS FLORSCHUETZ has lived and worked in Berlin since coming from the East in 1988.

GÜNTHER FÖRG was born in 1952 in Fussen, Germany. He studied at the Akademie der bildenden Künste in Munich.

ELFI FRÖHLICH, born in Luenen/Nordrhein-Westfalen in 1951, lives in Berlin.

ANDRÉ GELPKE studied with Otto Steinert in Essen. In 1974 he helped to establish the

Visum photo agency. He lives in Düsseldorf and Zurich.

ULRICH GÖRLICH, born in Niedersachsen in 1952, studied under John Baldessari at the California Institute of the Arts in 1982-83. He lives in Berlin.

SILKE GROSSMANN, born in 1951, attended the Hochschule für bildende Künste in Hamburg, where she lives.

Born in 1954, AXEL GRÜNEWALD's photographs have been widely exhibited and published. He lives in Bielefeld.

ANDREAS GURSKY, born in 1955, lives in Düsseldorf. He studied at the Kunstakademie Düsseldorf with Bernhard Becher.

Born in Stuttgart in 1924, ROBERT HÄUSSER has worked as a freelance photographer in Mannheim since 1952.

HEINZ HAJEK-HALKE (1889-1983) made his first photographs in 1924. In 1955 he was named a lecturer at the Hochschule für bildende Künste in Berlin.

MARKUS HAWLIK, born in 1951, received a degree in visual communication from the Hochschule für Grafik, Leipzig. He lives in Berlin.

DIETER HILDEBRANDT was born in 1932 in Berlin. Among his publications are *Saul/ Paul, a Double-Life* and *Berliner Enzyklopädie*.

SIEGFRIED HIMMER, born in Dresden in 1935, studied at the Staatliche Akademie der bildenden Künste in Stuttgart. He lives in Cologne.

VOLKER HINZ, born in 1947 in Hamburg, joined *Stern* magazine in 1974. He lives in Hamburg.

HANNAH HÖCH (1889-1978) was a central figure of the Dada movement in Berlin after World War I.

KLAUS HONNEF studied sociology before becoming a freelance journalist in 1960. Since 1974 he has been a director at the Rheinisches Landesmuseum in Bonn.

Born in Bad Pyrmont, ANDREAS HORLITZ studied in Essen from 1976 to 1980, and now lives in Cologne.

AXEL HÜTTE, born in Essen in 1951, studied at the Kunstakademie in Düsseldorf, where he now lives.

ENNO KAUFHOLD studied art history at the University of Hamburg; he works as a freelance photo historian, critic, and photographer in Berlin.

Born in Donaueschingen, Germany, in 1945, ANSELM KIEFER is one of the best known contemporary German painters.

ASTRID KLEIN was born in 1951 in Cologne, where she studied at the Fachhochschule für Kunst und Design.

JASCHI KLEIN, born in 1942, studied painting and photography at the Fachhochschule Kiel and the Hochschule für bildende Künste in Hamburg.

Born in Lindau, HERLINDE KOELBL has worked as a freelance photographer since 1975. An exhibition of her "Jüdische Portraits" will tour the United States in 1991-92.

MARTIN LANGER, born in Göttingen in 1956, studied at the Fachhochschule in Bielefeld, where he works as a freelance photojournalist.

ROBERT LEBECK, born 1929, has photographed for many publications, notably *Stern*. He lives in Hamburg.

ULRICH LINDNER, born in 1938, is a freelance photographer in Dresden.

HERBERT LIST (1903-1975) began photographing in Hamburg in the 1920s. He was later a successful magazine photographer.

UTE MAHLER, born in Berka near Sondershausen in 1949, studied photography in Leipzig from 1969 to 1974. She lives in Berlin.

ROGER MELIS is a freelance photographer in Berlin, where he teaches at the Kunsthochschule.

CLEMENS MITSCHER, born in Marburg in 1955, attended the Hochschule für Gestaltung Offenbach/Main.

STEFAN MOSES, born in 1928, worked as a stage photographer for the National Theater in Weimar after the war. From 1960 to 1967 he was a staff photographer for *Stern*.

STEFAN NESTLER, born in Freiberg in 1962, studied under Arno Fischer at the Hochschule für Grafik und Buchkunst in Leipzig.

ANGELA NEUKE studied photography under Otto Steinert at the Folkwang-Schule in Essen. Since 1967 she has worked as a photojournalist and teacher.

FLORIS M. NEUSÜSS, born in Lennep in 1937, has taught experimental photography in Kassel since 1971.

CARMEN OBERST grew up in Karlsruhe and in 1979 moved to Hamburg, where she now lives.

Born in 1951, HERMINE OBERÜCK studied social science and photojournalism. She lives and works in Bielefeld.

HILMAR PABEL, born in 1910, worked for the magazines *Quick* and *Stern* from 1950 to 1970; since then he has worked as a freelance photojournalist.

HELGA PARIS, born in 1938, studied at the Fachschule für Bekleidung in Berlin, where she lives.

Best known as a painter, SIGMAR POLKE was born in Oels in 1941 and studied at the Staatlichen Kunstakademie in Düsseldorf. He lives in Cologne.

BERNHARD PRINZ, born in Furth, Bavaria, in 1953, studied art history in Erlangen and studio art at the Akademie der bildende Künste in Nuremberg. He lives in Hamburg.

ALBERT RENGER-PATZSCH (1897-1966) studied chemistry in Dresden before taking up photography. His book *Die Welt ist schön* (1928) is a pioneering statement of the "New Objectivity."

DIRK REINARTZ, born in Aachen in 1947, studied photography under Otto Steinert before joining *Stern*. Since 1982 he has worked as a freelance photographer.

Between 1953 and 1956 EVELYN RICHTER studied photography at the Hochschule für Grafik und Buchkunst in Leipzig, where she now teaches.

JENS RÖTZSCH, born in 1959 in Leipzig, works as a freelance photographer in Leipzig and Berlin.

THOMAS RUFF, born in 1958, studied at the Staatlichen Kunstakademie in Düsseldorf, where he now lives.

AUGUST SANDER (1876-1964) worked as a commercial portrait photographer before beginning his famous series of portraits *Menschen des 20. Jahrhunderts* (People of the 20th century).

MAX SCHELER studied German and theater at the University of Munich and the Sorbonne, before becoming a photojournalist in 1949. He lives in Hamburg.

ERASMUS SCHRÖTER, born in 1956, studied at the Hochschule für Grafik und Buchkunst, Leipzig. He lives in Hamburg.

GUNDULA SCHULZE, born in Erfurt in 1954, studied photography at the Hochschule für Grafik und Buchkunst in Leipzig. She lives in Berlin.

FRIEDRICH SEIDENSTÜCKER (1882-1966) studied sculpture at the Berliner Hochschule before turning to photography. After World War II he documented the reconstruction of Berlin.

DR. OTTO STEINERT (1915-1978) became head of the photography program at the Kunstschule in Saarbrücken in 1948, moving in 1959 to the Folkwang School in Essen, where he remained until his death.

THOMAS STRUTH, born in 1954, studied in Düsseldorf with P. Kleemann, Gerhard Richter, and Bernd Becher.

CHRISTOPH TANNERT, born in Leipzig in 1955, was the editor of *Ursuspress*, and now works in Berlin as a freelance curator.

ULRICH TILLMANN, born in 1951, is a curator at the Agfa Foto-Historama of the Ludwig Museum in Cologne.

UMBO (Otto Umbehr, 1902-1980) photographed for the Dephot Agency from 1928 to 1933; later he taught photography in Bad Pyrmont, Hanover, and Hildesheim.

MARTIN WALSER, winner of the prestigious Hermann Hesse prize, is the author of numerous plays and novels, including *The Swan Villa*, *The Inner Man*, and *Breakers*.

WIM WENDERS worked as film critic before beginning to direct his own films. His films include *Paris, Texas*; *The Goalie's Anxiety at the Penalty Kick*; *The American Friend*; and *Wings of Desire*.

THOMAS WESKI studied sociology and psychology between 1976 and 1978. He is codirector of the Spectrum Photogalerie at Hanover's Sprengel Museum.

DR. WILFRIED WIEGAND, born in Berlin in 1937, studied art history, archaeology, and philosophy. He has worked as an editor for *Die Welt*, *Der Spiegel*, and the *Frankfurter Allgemeine Zeitung*, where he is editor of the culture section.

ULF ERDMANN ZIEGLER, born in 1959, is a critic for *Die Zeit* and *die tageszeitung*, and the author of the book *Nackt unter Nackten* (Naked among the naked).

WOLFGANG ZURBORN, born in Ludwigshafen in 1956, studied at the Bayerische Staatslehranstalt für Photographie in Munich and at the Fachhochschule Dortmund.

ACKNOWLEDGMENTS

A great many people, in Germany and the United States, have contributed time, energy, and ideas to help make this issue a reality. We would like to thank first of all the members of our Advisory Committee: Ulrich Domröse, Ute Eskildsen, Janos Frecot, Manfred Heiting, Klaus Honnef, F.C. Gundlach, and Peter Weiermair. For their gracious assistance we also thank: Thomas Weski; Michael Pauseback; Bernd Seiler and Jürgen Vorrath, Produzentengalerie; Michael Schmidt; Arno Fischer; Dr. Ulrike Gauss, Staatsgalerie Stuttgart; Lisa Spellman, 303 Gallery; Sara Ogger, Marian Goodman Gallery; Jörg Boström and Gottfried Jäger, Fachhochschule Bielefeld; Tony Kaes; and Ellen O'Donnell Rankin, Aldrich Museum of Contemporary Art, among many others.

Invaluable help in contacting photographers, and in discussing issues of Germany and German photography, was provided by Michael Wiesehöfer and Karsten Moll, Bielefeld—for which many thanks.

CREDITS

NOTE: In the following credits, dimensions are given for prints 24 × 36″ or larger, with the height listed first. Unless otherwise noted, all photographs are courtesy of, and copyright by, the artists.

Cover photograph by Jaschi Klein, 24 × 20″ Polaroid; p. 2 photograph by Dr. Otto Steinert, courtesy Folkwang Museum, Essen; p. 3 photograph by UMBO, courtesy Berlinische Galerie, Photographic Collection; p. 4 photograph by Hannah Höch, courtesy Berlinische Galerie, Photographic Collection; p. 5 photograph by Heinz Hajek-Halke, courtesy Berlinische Galerie, Photographic Collection; p. 6 top: photograph by Albert Renger-Patzsch, courtesy Albert Renger-Patzsch Archiv/Ann and Jürgen Wilde, Zülpich; bottom: photograph by Friedrich Seidenstücker, © Bildarchiv Preussischer Kulturbesitz; p. 7 photograph by August Sander, courtesy Berlinische Galerie, Photographic Collection; p. 12 top: photograph by Ellerbrock & Schafft, courtesy Bilderberg Archiv der Fotografen; pp. 15-16 photographs by Michael Engler, courtesy Bilderberg Archiv der Fotografen; p. 26-31 photographs by Herbert List, courtesy PPS. Galerie F.C. Gundlach, Hamburg; pp. 36-37 photographs by Caroline Dlugos, 64 × 47 1/2″; 66 × 50″; p. 42 photograph by Ute Mahler, courtesy Ostkreuz Agentur der Fotografen; p. 44 photograph by Ute Mahler, courtesy Ostkreuz Agentur der Fotografen; p. 48 photograph by Jens Rötzsch, courtesy Ostkreuz Agentur der Fotografen; p. 50 photograph by Hilmar Pabel, © Bildarchiv Preussischer Kulturbesitz; p. 52 photograph by Hilmar Pabel, © Bildarchiv Preussischer Kulturbesitz; p. 55 photograph by Elfi Fröhlich, 39 × 58 1/2″; p. 56 photographs by Bernd and Hilla Becher, courtesy Sonnabend Gallery, New York; p. 57 Bernhard Prinz, 59 × 70″, courtesy Produzentengalerie, Hamburg; pp. 58-59 photographs by Thomas Ruff, 83 × 65″, courtesy 303 Gallery, New York; pp. 60-61 Bernhard Prinz installation, background: *Clean Linen*, 1984/89. 16 parts, Cibachrome, 43 × 41″ each; Foreground: *Untitled*, 1989, sculpture installation. Photo: Werner Zellin, courtesy Produzentengalerie, Hamburg; p. 62 top: photograph by Axel Hütte, 82 × 96 1/2″, courtesy Galerie Rudolf Kicken, Cologne; bottom: photograph by Thomas Ruff, 65 × 78″, courtesy 303 Gallery, New York; p. 63 photograph by Andreas Gursky, 29 × 37″, courtesy Johnen & Schöttle Gallery, Cologne; p. 65 photograph by Günther Förg 47 1/4 × 71″, courtesy Luhring Augustine Gallery, New York, and Max Hetzler Galerie, Cologne; pp. 66-67 photographs by Bernd and Hilla Becher, courtesy Sonnabend Gallery, New York; pp. 68-69 photograph by Thomas Struth, courtesy Marian Goodman Gallery, New York; p. 71 photograph by Dieter Appelt, courtesy Galerie Rudolf Kicken, Cologne; p. 74 photograph by Floris M. Neusüss, 131 × 123″; p. 75 photograph by Ulrich Tillmann, 47 × 33″, courtesy Galerie Reckermann, Cologne; p. 77 photographs by Dörte Eissfeldt, from *Schneeball* (European Photography, 1990); p. 78 photographs by Pidder Auberger, top: 49 × 91″; bottom: 46 × 91″; p. 79 photograph by Astrid Klein, courtesy Produzentengalerie, Hamburg; p. 80 photograph by Walter Dahn, 63 1/2 × 48″, courtesy Mr. and Mrs. Michael Loulakis, Frankfurt; p. 81 photograph by Johannes Brus, courtesy Galerie Gmyrek, Bonn; p. 82 photographs by Bernhard and Anna Blume, Polaroid SX-70 collages, courtesy Galerie Philomene Magers, Bonn; p. 83 photograph by Sigmar Polke, courtesy Kunsthalle Baden-Baden and Galerie Erhard Walter, Bonn; p. 84 photograph by Thomas Florschuetz, 46 × 70″, courtesy Galerie du jour agnes b., Paris; p. 87 Anselm Kiefer, collage, shellac on photographic paper, 23 1/4 × 32 3/4″, courtesy Marian Goodman Gallery, New York; p. 89 photograph by Andreas Horlitz, Cibachrome, 25 × 35″, courtesy Galerie Alfred Kren, Cologne; pp. 90-91 photographs © Wim Wenders 1988, courtesy PPS. Galerie F.C. Gundlach, Hamburg.

CORRECTION: The photographer of Gran Fury's *Untitled*, 1990, installation at the Venice Biennale, which appeared on page 22 of "The Body in Question" (Aperture 121), is Shigeo Anzai. We are grateful for his contribution.

Linhof's World Views.

Linhof's yaw-free views.

The Kardan Master GTL and Kardan GT, with telescoping rails and tri-axial movement, yield yaw-free indirect as well as our traditional yaw-free direct displacements. Thus these large-format cameras are "yaw-free-er" than anyone's. And they are stable even under extreme extensions (8 x 10 with long bellows fully extended). 4x5, 5x7, and 8x10 models, with conversion and reducing kits to expedite format-changing are available. These are the most technically perfect view cameras you will see.

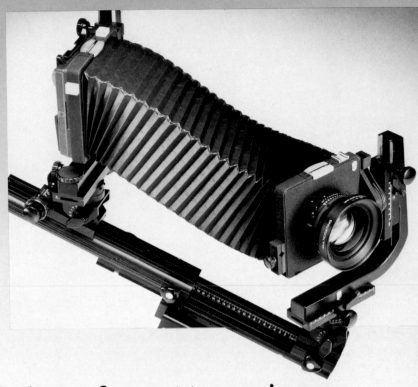

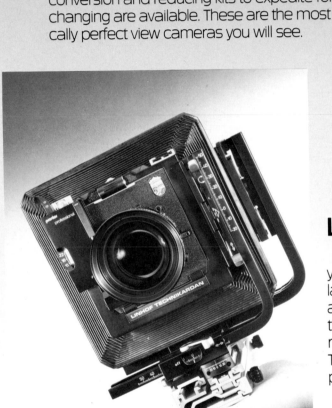

Linhof's large-format to go views.

The Linhof Technikardan 45 closes to only 8.5"x 10"x 4" (book size) — yet opens to 19" and uses lenses from 47mm to 600mm. It's a true large-format that goes outdoors and indoors. Rise, shift, swings and tilts are flawlessly performed. A unique Prontor shutter control allows aperture adjusting/reading from **behind** the camera. No fancy footwork required. And the TK 45 weighs only 6.5 pounds. Its smaller sister, the TK 23, weighs even less. The Technikardans are small in size but big in performance. See for yourself.

Linhof's widest views.

For large-format's exacting quality plus the convenience of roll film in a hand-held camera, Linhof's Technorama 617S and 612PC II are revelations. The travel/scenic, architectural, interior and industrial images they capture are breathtakingly unique. Both have an integrated spirit-level for exact camera positioning; brightline viewfinder with cross hairs; exposure times from 1 to 1/500 second and B; aperture settings from f5.6 to f45 in ½-stop increments; and more.

The 617S yields superbly detailed 87° shots in a film area 3 times larger than 2¼x 2¼; using a Schneider Super Angulon 5.6 90mm lens in precision helical focusing mount. The 612PC II has 2 interchangeable lenses, a 5.6 65mm and 5.6 135mm; a built-in lens pre-shift for perspective control; and takes up to 86 images twice as large as 2¼x 2¼. Both cameras give wide, wide views that are distortion-free with straight and no converging lines.

Consider Linhof's views at any authorized Linhof dealer.

Linhof
When your decision is precision.

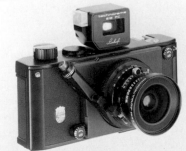

Marketing Corp.
16 Chapin Rd., Pine Brook, NJ 07058, 201/808-9010
In Canada available through: Daymen Photo Marketing Ltd., Scarborough, Ontario M1V2J9

We give you the most ways to view the world.

In all the world, Rodenstock has the largest selection of large format and enlarging lenses. This system gives you the greatest chance to solve *any* photographic problem—without sacrificing any quality. Because overall, Rodenstock lenses have superior speed, edge-to-edge sharpness, coverage and absolute color fidelity from lens to lens. And our technical support to you is second to none.

What makes Rodenstock, Rodenstock.

For over 110 years, Rodenstock's high German standards have remained intact: in the design, the manufacturing, and in the measurement techniques/equipment that ensure you superior quality lenses. All applicable scientific data from our Research & Development staff, unique experiences in laser-optics

electronics and NASA space programs go into every Rodenstock lens.

Unduplicated views.

We offer uniquely designed lenses which enable you to see the world in special ways. Our Macro Sironar, for example, is 2 lenses in 1: it adjusts from $\frac{1}{3}$ lifesize to lifesize to 3 times lifesize. Imagon is continuously variable from very, very soft to very, very sharp. It is *the* soft focus lens.

You're already looking at Rodenstock.

No single lens can handle every situation. Not yet, anyway. And lenses of questionable quality can ruin your reputation. View your world through Rodenstock. 2 out of every 3 process cameras use our lenses, so chances are you're viewing the reproduced world through Rodenstock already.

Rodenstock
The world's greatest depth of quality.